PHL

KU-724-430

Trade in antiquities
Reducing destruction and theft

THE

PAUL HAMLYN
LIBRARY

WITHDRAWN

TRANSFERRED FROM

THE

CENTRAL LIBRARY
OF THE
BRITISH MUSEUM

2010

TRADE IN ANTIQUITIES
Reducing Destruction and Theft

Patrick J. O'Keefe

UNESCO
Publishing

Archetype
Publications

THE
BRITISH
MUSEUM
THE PAUL HAMLYN LIBRARY

364 · 162 OKE

Published jointly by Archetype Publications Ltd and United Nations
Educational Scientific and Cultural Organization

Archetype Publications
6 Fitzroy Square, London W1P 6DX

UNESCO
7, Place de Fontenoy, 75700 Paris

© 1997 UNESCO

Archetype Publications ISBN 1 873132 31 X
UNESCO Publishing ISBN 9 231034 06 5
Printed in Great Britain by Henry Ling Ltd., at the Dorset Press, Dorchester, Dorset

The designations employed and the presentation of material throughout this publica-
tion do not imply the expression of any opinion whatsoever on the part of the UNESCO
Secretariat or Archetype Publications concerning the legal status of any country,
territory, city or area or of its authorities, or the delimitations of its frontiers or
boundaries.
 The author is responsible for the choice and the presentation of the facts con-
tained in this book and for the opinions expressed therein, which are not necessarily
those of UNESCO and do not commit the organization.

All rights reserved; no part of this publication may be reproduced, stored in a retrieval
system, or transmitted in any form or by any means, electronic, mechanical, photo-
copying, recording or otherwise, without the prior permission of the Publishers.

Cover Illustration: Christ fragment from the Kanakariá mosaics. (Photograph C. Sease),
reproduced with the kind permission of the Department of Antiquities, Republic of Cyprus.

4173

EB (DKE)

I would like to thank all those who contributed their expertise and time in providing information for this Report. I would also thank those who read and commented on the draft. Some have asked that they not be mentioned by name and so I do not name anyone. However, I would particularly thank the Society of Antiquaries of London which organized a meeting of various people concerned with the trade; the International Foundation for Art Research and the Art Law Centre who helped with introductions; the Art Newspaper which included an article on the project.

Contents

Introduction

There appears to be a rising demand for antiquities; not only for those of museum quality but, more broadly, for ones suitable for decoration. Under existing conditions, this can only lead to theft from collections and, even more significantly, to a worsening of the already widespread destruction of sites and monuments important to humanity's history. The reason is simple: there is only a finite supply of antiquities legitimately available to the trade. Moreover, as objects move into permanent collections, the legitimate supply diminishes. Any increase must come from other, illegitimate sources.

It is wishful thinking to expect, in the immediate future, the demand for antiquities either to fall off of its own accord or for measures taken now to immediately limit demand. Satisfying demand in the short term would give time for measures to operate to lessen or redirect it in the long term. How can this be done in order to avoid destruction and theft whilst ensuring that humanity does not lose the records of its past?

In the short term, demand might be satisfied by increasing the flow of objects onto the market. But long term policies – particularly in education – need to be implemented now to alert people to the damage caused by acquiring antiquities coming from illegitimate sources; to render acquisition from such sources anti-social and financially unattractive; to ensure that chance finds are dealt with fairly for all parties concerned.

Many arguments are made for increasing the flow of antiquities or limiting it further, but they are usually mere assertions. This Report is an attempt to look at those arguments in more depth – will they really help to limit the illicit trade? Legalizing what is now illegal will not solve the problem if sites, monuments and collections continue to be damaged and destroyed – destruction is destruction whether legal or not.

There is a proper place for a licit trade in antiquities coming from existing collections; from chance finds or from authorized excavations where disposal of the antiquity has been permitted by governments acting on the advice of their services responsible for cultural matters. Those who wish to acquire objects for

1

their aesthetic or other attributes should be free to do so provided they come from such a legitimate source.

The concept of legitimate and illegitimate source is used in order to avoid legal terminology. The law applying to the trade in antiquities is complex. What may be the perfectly lawful possession of an antiquity in one country may be considered by another as a crime. What for one country is unlawful export is to another of no legal consequence. On the other hand, what is a legitimate source and what is not rests on a value judgment that certain things should be preserved for the purpose of learning the story of humanity's past. There needs to be a wider understanding of the importance of preservation and this can be achieved only by education.

Collecting and controversy

Collecting antiquities is of increasing popularity. In part this is a factor of hype by leading auction houses and well publicized exhibitions of existing collections.[1] Television documentaries[2] and shows,[3] popular fiction[4] and films[5] have dealt with antiquities in such a way as to capture people's attention; often linking the search for them to mystery, romance and adventure. In part collecting is probably also an aspect of the general increase in public interest in the past that has occurred this century.[6]

Collectors see themselves as performing a public service by their assembly of beautiful objects produced by past creators. Ortiz said of his collection – mainly antiquities – when it was exhibited at the Royal Academy of Arts in London:

> The collection you will see is a message of hope, a proof that the past is in all of us and we will be in all that comes after us. Let these works of art speak to you, hopefully some of them will move you by their beauty and reconcile you to your fellow men however different their religions, customs, races or colour. For these works of art are the product of humanity.[7]

[1] For example, the Ortiz Collection shown, among other places, at the Hermitage, St. Petersburg in 1993 and at the Royal Academy of Arts, London, 1994; the Fleischman Collection at the J. Paul Getty Museum and the Cleveland Museum of Art, 1995

[2] Two examples are the major BBC productions 'Archaeology of the Bible Lands' and 'Civilization'

[3] In England, the series 'Going for a Song' and 'Antiques Roadshow', both featuring members of the public offering objects to a panel of experts for assessment, have proved very popular.

[4] For example, Clive Cussler in *Inca Gold* (1994) and *Treasure*; Wilbur Smith – *The Seventh Scroll* (1995); Lincoln Preston – *Relic* (1995); Alan Gold – *The Lost Testament* (1994).

[5] The character, Indiana Jones, as an archaeologist in *The Lost Ark*, *The Temple of Doom* and *The Last Crusade*.

[6] Lowenthal, D. The Past is a Foreign Country (Cambridge University Press, Cambridge, 1985): 365.

[7] Ortiz, G. 'In Pursuit of the Absolute' in *In Pursuit of the Absolute: Art of the Ancient World From the George Ortiz Collection* (Royal Academy of Arts, London, 1994): 4, 8.

Collectors sometimes also see themselves as but guardians of the antiquities in their collection.

> The commitment to conservation and presentation demonstrated by the Fleischmans' support for the Bassai frieze project is equally evident in their own collection. Since most of their objects have already survived two millennia or more, they are determined that these pieces will be passed on, thoroughly researched and in the best possible condition, in the endless chain of preservation. 'We are the temporary custodians,' both are quick to remind the visitor, but they are concerned and devoted guardians.[8]

Others speak of their love for the antiquities they have collected and the thrill they experience in making an acquisition. The then director of one of the world's major museums entitled a piece 'The Chase, the Capture' and commences it with these words:

> The chase and the capture of a great work of art is one of the most exciting endeavours in life – as dramatic, emotional, and fulfilling as a love affair.[9]

The scholarship of serious collectors has also been praised.

> Those few collectors still around who buy such bronzes buy on the strength of their visual knowledge, which is tested over many years. They are the last generation of private collectors. After them, the knowledge will be gone, because the pieces on which it was built will no longer be circulating freely. Museum curators and art historians will take over, and it will be a different kind of knowledge – bookish, dispassionate.[10]

But collectors have been called 'looters'[11] – persons whose unbridled lust for possession destroys the history of humanity. Renfrew refers to Ortiz in these

[8] True, M. and Kozloff, A. 'Barbara and Lawrence Fleischman: Guardians of the Past' in Harris, J. (ed.) *A Passion for Antiquities: Ancient Art from the Collection of Barbara and Lawrence Fleischman* (The J. Paul Getty Museum, Malibu, 1994): 6.

[9] Hoving, T. in *The Chase, the Capture: Collecting at the Metropolitan* (Metropolitan Museum of Art, New York, 1975): 1.

[10] Melikian, S. 'The Expert Said So' (1994) *Art and Auction* (October): 112, 118.

[11] Elia, R.J. in a review of Renfrew, C. *The Cycladic Spirit: Masterpieces from the Nicholas P. Goulandris Collection* (Abrams, New York, 1991) in (1993) *Archaeology* January/February: 64, 69.

terms:

> The collection of Mr George Ortiz was recently shown in the Royal Academy. It is our job collectively to deprecate this, and to ensure that Mr Ortiz goes away a little more ashamed than when he came since he is doing the past great damage by financing the large scale looting which is the ultimate source of so much of what he is able to exhibit.[12]

Collectors are accused of motivating the dismemberment of collections where security has disappeared in the course of armed conflict.

> As long as there are acquisitive collectors driven by their obsession to own what no one else can obtain, the uniqueness of items from the Kabul Museum make them irresistible and thus a source of inestimable value to the well-organized, avaricious looters and their agents.[13]

Which of these portrayals of collectors is accurate? Do both have validity? If so, can they somehow be made to co-exist?

Then there is the person who buys a few antiquities for their decorative effect. This person usually has little interest in their origin besides the fact that they are old – which carries a certain cachet – and they need not be particularly valuable provided they are 'pretty' or interesting. Such a person is not a collector in the sense discussed above. From conversations with dealers and from other sources, there are indications that this demand for antiquities as decorative art is increasing substantially. What effect will this development have on the sources of antiquities? Are the methods in use now to protect those sources appropriate to the type of antiquity involved?

Choosing the correct answers to all the questions posed in this section is vital. If the wrong decision is taken, then much that is central to humanity's knowledge of itself, both in the past and now, will be lost. But any decision will be influenced by the different interests at play.

[12] Renfrew of Kaimsthorn (Lord) 'Introduction' in Tubb, K.W. (ed.) *Antiquities: Trade or Betrayed: Legal, Ethical and Conservation Issues* (Archetype, London, 1995): xvii, xxi.

[13] Dupree, N.H. 'Recent Happenings at the Kabul Museum' (1996) *SPACH Newsletter* 2: 1, 3.

Interests

There are many such interests but here there is space to discuss only some: those of archaeologists; impoverished local populations; indigenous peoples; dealers and auction houses; art historians; collectors and, finally, but most importantly, the general public.

Archaeologists

Archaeologists assert an interest in the study of the material remains of humanity; the requirements of their profession necessitate that some cultural material remains where it is; that active means be taken to preserve it; that what is moved is moved in a particular way and that, though most of it needs to be preserved, selection processes be applied. Some material, though in minute quantities, may even need to be destroyed for the purpose of testing. Archaeologists' claims really amount to one guiding rule or standard: that cultural material be treated in such a way that present or future knowledge is not destroyed. In this, they see themselves as representing the public, not only present, but future generations.

Impoverished local populations

For people with little resources the taking of antiquities from sites and monuments for sale may be a way out of an economic stranglehold for them and their children. They may see the antiquities as either having no relationship to their society and people or as a resource passed on to them by their forebears to be used for their betterment. This is a short-term interest in that inevitably the source of antiquities will disappear. It may destroy those peoples' access to aspects of their own culture. Moreover, in purely practical terms, the prices they obtain for what they sell are usually only a fraction of what the objects are worth on the international market.

Indigenous peoples

Recent years have seen indigenous peoples emphasizing their interest in antiquities originating with their ancestors. [14] Their claim is to control such antiquities for their own benefit. Having lost much of their history to conquest, colonialism and the destruction of their societies, they now need to relearn who they are and where they came from. Antiquities can help in this process but not when placed in a Eurocentric aesthetic setting.

> Placement of Maya objects within this corpus [primitive art] divorces them not only from the world of context as recognized by the archaeological community but also from any existing or potential contextual world created by the descendants of the people who made them. It does this initially by redefining the objects as part of Western rather than Maya culture, then by replacing issues of ancient symbolic and practical function with issues of modern Western esthetics, and finally by categorizing the objects as commodities to be traded on the world's markets.[15]

Another interest is in ensuring that the object is treated according to the beliefs of the people concerned even if this means its destruction; every offensive treatment of their cultural objects is a denigration of their cultural tradition.

Dealers and auction houses

The primary interest here is to have a stock of antiquities for sale without any legal problems attaching to the transaction from the way in which the antiquity was obtained. Consequently, this group will want access to the sources of antiquities to be as free as possible. At the same time, they will want to avoid adverse publicity arising from possession of antiquities alleged to have been obtained in dubious circumstances. In particular, they do not want clients facing

[14] For example, the *Mataatua Declaration on Cultural and Intellectual Property Rights of Indigenous Peoples 1993* reproduced in (1995) *International Journal of Cultural Property* 4:383; *Principles and Guidelines for the Protection of the Heritage of Indigenous People* United Nations Economic and Social Council Doc. E/CN.4/Sub.2/1995/26.

[15] Pendergast, D.M. 'Looting the Maya World: The Other Losers' (1994) *Public Archaeology Review* 2 (September): 3.

claims by governments or other collectors for return of an antiquity following theft or unlawful export. This is bad for business and bad for the reputation of the dealer or auction house.

Art historians

The function of the art historian is to analyse artistic developments over the whole of humanity's existence. It involves analysis of objects in terms of aesthetics. Consequently, the interest of the art historian will be primarily in the perfect object or the best example of a certain period or style. Fragmentary or damaged objects may also be important for the study of meaning, construction and development of periods and forms. Sometimes the art historian will be required to place an unknown object within a particular time frame and place. This necessitates a knowledge of the possibilities and a sense of what is right and fitting aesthetically. The art historian thus needs access to comparative material.

Collectors

Collectors of antiquities are many and varied. Their primary interest is in having antiquities to collect. Beyond that there is great diversity of interest. There are persons of modest means whose needs are satisfied by a collection of objects of no special significance or for decoration. On the other hand, there are persons of great wealth who search for the perfect object.

> Little by little over the past forty-three years, the collection has grown more and more into a coherent whole. Objects came my way, and some of them unquestionably because they had to do so. It is as though, imbued with the spirit of their creator, they came to me because they knew I would love them, understand them, would give them back their identity and supply them with a context in keeping with their essence, relating them to their likes.[16]

Collectors such as museums need a range of antiquities for educational purposes as do universities. But another great distinction between all collectors is in their attitude to acquisition. Some will collect only antiquities with an unblemished history; others ignore even knowledge of theft or clandestine excavation while yet others, perhaps the majority, do not investigate too deeply.

[16] Ortiz, fn. 7: 5.

Public

While some of the interests asserted above relate directly to individual economic or other benefits, others are more closely related to the welfare of the public at large. Thus, archaeologists see themselves as acting on behalf of the public, guardians of antiquities and of all that can be learned from them and their context. Dealers and collectors, in asserting the significance of cultural exchanges, emphasize the importance of exposure to exotic cultural traditions for the stimulation of creativity and education of the public. To respond to both of these interests, the maximum value must be extracted from all antiquities. This includes not only the historical information that can be extracted from the object in its context but also the aesthetic experience to be gained from viewing certain of them in collections. As these follow in logical sequence, both groups represent a primary interest of the public in seeing that the historical information is extracted before antiquities are put to other uses.[17] But this goes directly to the problem involved in collecting and trade in antiquities.

[17] See further p.101. It must be admitted that this is a largely Eurocentric notion but one that has so pervasively penetrated the rest of the world that it cannot be denied: note Lowenthal, D. 'Conclusion: Archaeologists and Others' in Gathercole, P. and Lowenthal, D. (eds.) *The Politics of the Past* (Unwin Hyman, London, 1990): 302.

The problem with trade and collecting

Antiquities are objects that are the surviving material traces of people who lived before us. The word is used in the legislation of certain countries with this meaning; as, for instance, in the 1993 *Sarawak Cultural Heritage Ordinance* where 'antiquity' means:

> (a) any object, whether movable or immovable or a part of the soil, which has been constructed, shaped, painted, carved, inscribed, erected or otherwise produced or modified by human agency and which is or is reasonably believed to be at least one hundred years old ...

The one hundred year qualification emphasizes that an antiquity is an object with some age.[18] But even that does not convey the real meaning of 'antiquity'. There is no intention to here formulate a precise definition. It is enough to say that this study is mainly concerned with objects made or modified by humans; of a considerable age; often obtained by chance from their hiding places, by excavation of the soil or detachment from monuments.

Collecting such antiquities and the trade in them is an ancient one.

> Around 180 BC Eumenes II built the famous Altar at Pergamum. He collected 'art treasures of some antiquity' and his brother Attalus II 'old paintings' – evidence that even at this period antiques were being hoarded and 'famous old murals, which were not purchasable, copied'.[19]

> Alexander at Pella, moved by a nostalgia for the purity of ancient Athenian civilization, became a collector of antiquities. The Hellenistic monarchs began systematically and reverently to collect the ruins and the fragments of

[18] In *United States v. Diaz* 499 F.2d 113 (1974) the court was somewhat nonplussed by a professor of anthropology giving evidence to the effect that face masks made by a Native American in 1969 or 1970 were objects of antiquity because they related to religious and social traditions of long standing.

[19] Arnau, F. *Three Thousand Years of Deception in Art and Antiques* (Translated from the German by J.M. Brownjohn, Jonathan Cape, London, 1961): 24.

the classic age and Sicyon became the gathering place for the art dealers of the empire.[20]

In the sixteenth century in Europe there came into being the 'cabinet of curiosities' established and maintained by kings, princes and gentlemen of scholarship.

> The concept of 'antiquities' embraced the whole range of available material evidence, natural and cultural, oral and written. Collectors combing their neighbourhoods drew few distinctions between an inscribed parchment, a shard of pottery, and a geological specimen. To the real antiquary, announced Sir John Simeon in 1859, 'every relic he picks up or secures, is pregnant with instruction, as bearing upon the history or the social life or habits of some past age'.[21]

But the desire for antiquities should not be regarded as confined to Europe.

> Of Chinese antique collecting, it is almost enough to say that antiques in astonishing variety were pursued as prizes by Chinese collectors during many centuries before Mao Zedong's revolution. Ancient bronzes had been taken from earliest times by tomb robbers for the value of their metal; but they began to be sought in another way – in fact, by antique collectors – in the Song dynasty [10-13th centuries]. A mention has already been made of the Emperor Hui Zong's lost bronze collection, but there were many other Song bronze collectors, too, and the Song dynasty further produced a substantial body of antiquarian writing on the subject of the ancient bronzes. At this period, ancient jades also began to be collected ...[22]

In recent times the notion of antiquity has become more refined and the scope of collecting has expanded. Today there are probably more collectors of antiquities than ever before in the world. But this creates a problem – the volume of antiquities on the market legitimately cannot equal the demand. The sources are limited and fixed.

[20] Taylor, F.H. *The Taste of Angels: A History of Art Collecting from Rameses to Napoleon* (Little Brown and Co., Boston, 1948): 15.

[21] Griffiths, T. *Hunters and Collectors* (Cambridge University Press, Melbourne, 1996): 21.

[22] Alsop, J. *The Rare Art Traditions* (Harper and Row, New York, 1982): 249.

Sources of antiquities

There are three such sources: disposals from existing collections; removals from monuments (i.e. structures and remains of structures); excavations or chance finds. These three sources cannot change. Availability of antiquities for collectors depends on how the market is regulated either by government or economic forces.

Collections

The first source cannot keep the market supplied by itself unless the demand lessens.[23] Collections held by public institutions are rarely disposed of. Private collections are often gifted to public institutions from which they do not emerge. Over time the volume of antiquities moving among collections would get smaller and smaller if it were not topped up from the other two sources.

Monuments

However, the second source is itself limited. There are only a certain number of monuments in the world and not all have antiquities which can be physically removed. Where they can be physically removed, there are nearly always good reasons why they should not be.

Finds

Chance finds and discoveries through excavation are the main source for replenishing the international trade in antiquities. The circumstances where these occur are many and varied. Quite apart from those resulting from deliberate search for antiquities, numerous finds are made during excavations for construction projects and change in the usage of land.

[23] We note the argument made by Isler-Kerényi ('Are Collectors the Real Looters?' (1994) *Antiquity* 68: 350, 351) regarding the stable market for antique carpets but the supply of such carpets is relatively inelastic while that of antiquities is elastic under current conditions and, as we have said, we consider it wishful thinking to expect the demand for antiquities to fall off of its own accord in the immediate future.

Legal restrictions

The volume of material entering the international market for antiquities is also influenced by the local legal regime. In many States the search for antiquities requires a permit. Any that are found, or any found by chance, may be owned by the State. Only in the event of the State relinquishing ownership does the finder or excavator have the right to deal with them. Thus, in England, under the laws of treasure trove, certain antiquities are owned by the Crown when they are discovered and their discovery must be reported. In practice the Crown will pay a reward if it wants to keep them. Otherwise, they will be returned to the finder or excavator – not the owner of the land.

In Sweden, ownership of specified categories of antiquities vests in the finder who has a duty to offer them to the State in return for a payment calculated according to criteria laid down in the legislation. Only when the State determines that it has no interest does the finder have the right to deal with the objects. The State thus has the right to extract the most significant pieces before the material from this source reaches the market. In virtually all States, certain monuments are protected and removal of integral parts of the structure is an offence. The person who removes an antiquity by taking it from the monument does not acquire ownership in that State.

Even in cases where a person has ownership and possession of an antiquity, there may be a prohibition against exporting it from the State or other jurisdiction where it is located. Its owner is not free to deal with it outside the local market which itself may have internal restrictions on transfer of ownership.

Various legal regimes thus influence the flow of antiquities onto the international market. This is done in the name of certain values which the jurisdiction concerned rates higher than keeping the market supplied with antiquities: values such as preservation of sources of knowledge, maintenance of monuments and sites, local pride, nation building, encouraging tourism.

Market demands

Persons ignore the restrictions mentioned in order to feed the demand for antiquities and, in doing so, destroy sites and damage monuments. Market demand leads to breaches of the law designed to protect the rights of individuals and the public. Failure by collectors to respect these laws and adequately investigate the origin of the antiquities they buy has grave consequences for the

survival of the history those antiquities can impart and, indeed, for the continued existence of associated antiquities of lesser, or no, market value.[24]

Destruction

The destruction of sites by persons excavating for antiquities without using proper archaeological techniques and without the necessary permits – in other words, looters – is too well known to require detailed substantiation. Much has been written of the situation in all parts of the world.[25] The destruction occurs in the search for objects with a particular aesthetic or perhaps historic attraction that will have a high monetary value on the international art market. In the course of such search the historic and scientific context is lost and often lost too are objects in themselves of little monetary value..

> Stratigraphic excavation, detailed record keeping, rigourous questioning, painstaking analyses: these are what trained archaeologists bring to their endeavours and what makes archaeology work. These elements are lacking in the hasty digging of looters. Looters sometimes find beautiful and curious objects. They always destroy much more. Their efforts deprive us all of the chance to learn the meaning of and the story behind the beautiful objects and the small simple chips of stone.[26]

The objects may be unrecognizable.

> Archaeological objects are often utilitarian and are the products of craftsmen and artisans. They will frequently have deteriorated to the point where they seem unrecognisable and yet preserve jewels of information within themselves to the informed observer. Two tassels from the 8th century BC grave of the wife of an Assyrian king discovered by archaeologists at Nimrud illustrate this point. The tassels now look like cylindrical, heavily corroded

[24] For example, as occurred when Hatcher raised ceramics from the wreck of the *Geldermalsen*, destroying their packing and parts of the vessel in the process: Thorncroft, A. *The Nanking Cargo* (Hamish Hamilton, London, 1987).

[25] Some examples: Meyer, K.E. *The Plundered Past: The Traffic in Art Treasures* (Readers' Union, London, 1974); International Council of Museums *Illicit Traffic of Cultural Property in Africa* (International Council of Museums, Paris, 1995); Gill, D.W.J. and Chippindale, C. 'Material and Intellectual Consequences of Esteem for Cycladic Figures' (1993) *American Journal of Archaeology* 97: 601.

[26] Vitelli, K.D. 'Palaeolithic Obsidian from Franchthi Cave: A Case Study in Archaeological Context' in Vitelli, K.D. (ed.) *Archaeological Ethics* (AltaMira, Walnut Creek, California, 1996): 24, 28.

copper tubes with threads passing through them. They are green and rather powdery and appear to have been wrapped with thread or textile.[27]

The destruction is enormous.

Those of you who have never seen a site destroyed by plunderers have no idea of the amount that gets destroyed. I would say roughly that what comes out of a commercial dig is between five and ten percent of what was to be found, without even considering the destruction of documentation, which is, of course, a catastrophe.[28]

Even where the object itself survives, there is often damage:

Finally, Plate 30 shows a pair of gold spools. The spools contain pellets that rattle when the spools are shaken. The edges of the spools are bent and misshaped. The Republic learned in its investigation that the thieves, when they heard the rattle sound, thought the spools might contain jewels, and tried to pry them open. The telltale marks of the mutilation remain and are a testament to the type of damage to which antiquities are exposed when they are handled in the black market by those seeking no goal other than profit.[29]

Much of the historic and aesthetic value of monuments is destroyed by the physical removal or even destruction of antiquities which are an integral part of the structure. Once again, the record is indisputable. One has only to look at the situation in Angkor; of the Mayan temples in Central America and of Tana Toraja in Indonesia to see this.

For Western art dealers to commission the theft of but one ancestral image from Tana Toraja would be a crime of serious magnitude. By 1988, however, almost all traditional burial sites had been disturbed by thieves, and hundreds of intact statues had been taken from Tana Toraja. Some museum directors and gallery curators justify their removal by saying that such fine

[27] Tubb, K.W. 'The Antiquities Trade: An Archaeological Conservator's Perspective' in Tubb: fn. 12, 256, 259.

[28] Melikian, S. 'A Degree of Destruction Unprecedented in the History of the World – And Yet I Support Collecting', The Art Newspaper, No. 52, October 1995: 27.

[29] Kaye, L.M. and Main, C.T. 'The Saga of the Lydian Hoard: from Usak to New York and Back Again' in Tubb: fn. 12, 150, 160.

works of art are so valuable a part of the artistic inventory of Southeast Asia that leaving them exposed to the elements in Tana Toraja would be negligent. Others say that the statues are no longer significant or meaningful to the Toraja and are willingly sold by villagers who have new personal and family concerns in a changing world.

Such obfuscations cannot mask the terrible rape of the Toraja ancestors that has occurred since the mid-1970's. So brazen has been this attack on ancestral tradition that even the two famous Toraja tourist sites, the burial caves and gallery at Londa and the great gallery at Rantelemo, have been looted of practically all their precious statues.[30]

Theft from collections

Market demand also results in theft from collections of antiquities.

It is clear that once the news of the state of the Museum [Kabul Museum] surfaced, the demand abroad for pieces from the collection, to a large extent, drove the looting. From the very beginning, it was evident that the intruders knew exactly what they were looking for.[31]

The number of thefts of antiquities from collections worldwide is unknown and probably incalculable. Not all such thefts are reported. Where they are, the police often do not distinguish them statistically from thefts in general. However, according to the best of sources, theft from collections is substantial. The collections concerned may be those held by individuals or by museums and similar public institutions. Many are located in churches and other places of worship. The level of security provided varies enormously. In many cases it is virtually non-existent – being either too costly or at odds with the purpose which the antiquity serves, such as the religious significance of a statue in a church or a carving in a temple. War, civil disturbance or change in the social order may mean the absence of adequate protective measures. Even where security is good there have been significant thefts.

[30] Crystal, E. 'Rape of the Ancestors: Discovery, Display, and Destruction of the Ancestral Statuary of Tana Toraja' in Taylor, P.M. (ed.) *Fragile Traditions: Indonesian Art in Jeopardy* (University of Hawaii Press, Honolulu, 1994): 29, 34.

[31] Leslie, J. 'Lost and Found' (1996) *SPACH Newsletter* 2: 2, 3.

Protecting the sources

It is thus of paramount importance to reduce the level of destruction of sites, damage to monuments (i.e. destruction of the sources of antiquities) and theft from collections.

Reducing destruction and theft

The following paragraphs look at methods currently in use under the general rubric of protecting the cultural heritage, including antiquities. In the main these have been implemented by States but there are some, potentially very effective, which have been adopted by independent or private bodies.

Some solutions aim directly at reducing the acquisition of heritage items, however these may be defined. Others aim to do this indirectly by facilitating the recovery of heritage. The return of an antiquity may undo a theft from a collection but it cannot undo destruction of context brought about by clandestine excavation. However, it is argued that publicity about returns will deter other dealers and collectors from entering into transactions involving unprovenanced antiquities. In other words, it is hoped that requiring the return of unlawfully traded cultural objects will ultimately reduce demand for antiquities where the provider cannot show that the buyer will have quiet enjoyment of them. Normally, one would expect that a buyer who knows he or she may have to return objects should be much more careful in acquiring them. This would reduce the market for unlawfully excavated antiquities and so limit destruction. However, the efficacy of this argument depends on the likelihood of the buyer eventually losing the object. If that is remote, such methods will have little effect on theft and on destruction of the sources of antiquities. Consequently, the question must be asked: How effective are the current methods for preventing or reducing destruction and theft?

Controls

Most States have legislation in place controlling aspects of the trade in antiquities. However, it must be admitted that in many cases these controls are not effective. A major problem is funding. Many States do not allocate sufficient funds to provide for effective enforcement and operation of the legislation. This is a widespread problem which exists not only in developing countries but also in a number of those classified as developed. The complaint is often heard that politicians think the problem is solved when the legislation is passed and forget

about what is needed to make it work properly.[32] On the other hand, it may be that the funds are not available or that the government has other priorities. But this is only part of a range of attitudes to the treatment of antiquities.

Some people, even senior officials, may see the sale of antiquities as a source of income for what they regard as development projects.

The protection of cultural relics should be adapted to the new situation of the market economy and made to serve economic construction.[33]

On the other hand, an uneducated population may not recognize the value of the history beneath their feet because they do not know what it means in terms of their own history or the history of the place where they live.[34] Economic pressures may lead them to mine it in exchange for a pittance compared to its value on the international art market.[35] There will be little co-operation with official attempts to implement the legislation. Poorly trained and ill-paid enforcement personnel will not assist or will ignore orders from higher officials.

The sheer logistics in terms of number of sites, distance and communication will often render enforcement impossible under any terms that make economic and practical sense. This is a major problem for developing countries. For example, of Mali the question has been asked:

Does anyone really advocate that Mali devote more than the 2% of its GDP

[32] For example, the *Protection of Movable Cultural Heritage Act* 1986 (Australia) provides for the creation of a National Cultural Heritage Fund. It was intended that the Fund would be used to enable public institutions to acquire objects refused an export permit. No money has ever been placed in the Fund although it was agreed in 1987 that both state and Federal Governments would contribute.

[33] Chinese Politburo member, Li Tieying quoted in Murphy, J.D. 'The People's Republic of China and Hong Kong' in Institute of Art and Law *Art Export Licensing and the International Market* Papers from a Seminar held in London on 19 March 1996 (Institute of Art and Law, Leicester, 1996): 2.

[34] This is a simple fact and the people concerned cannot be blamed. The situation can be changed by education – see p. 90. It is inequitable to use this as an argument for removal of antiquities, particularly when local people are employed to do the work and do not know what they are destroying.

[35] Pendergast states that the local digger is likely to receive 'one one-thousandth or less of the amount paid by the collector' if the route to the collector is other than direct: Pendergast, fn. 15, 3. This is borne out by evidence in significant cases: in *Attorney-General of New Zealand v. Ortiz* the excavated Maori carving was sold in New Zealand by its excavator for NZ$6,000 and five years later in London was alleged to be worth Stg.£300,000; the Shiva Nataraja at issue in *Bumper Development Corp. v. Commissioner of Police for the Metropolis and others* was sold by its discoverer in India for the equivalent of Stg.£12 and bought in London six years later for Stg.£250,000.

presently spent on the military, in order to garrison each and every archaeological site?[36]

But it is also a problem in the wealthiest of States. For example, in England, it has been established that at least 188 scheduled ancient monuments have been raided since 1988 – some many times.[37] Only countries with very few sites and monuments would have the ability to provide effective physical protection for every such source of antiquities. As for collections, it is doubtful if any system of security can be devised which is totally proof against penetration. Nevertheless, controls do have a role to play.

Excavation

Excavation without a permit, where this is required, may mean that any object taken is classified as stolen under the law of the State concerned if it is the owner of all undiscovered antiquities. It may also be so classified in foreign courts.[38] Even if in the particular circumstances this is not the case, the fact that the object has been unlawfully excavated will taint its possession. There will be no chain of holders leading to an acceptable provenance.[39] But it must be recognized that these consequences depend on recognition of the object as being unlawfully excavated. In general, if there is no documentation, it is impossible to distinguish a recently excavated antiquity from one which has been long in circulation. Certain aspects might arouse suspicion. For example, objects 'caked with mud and straw' as were those at issue in *United States v. McClain*,[40] would not seem

[36] McIntosh, R.J.; Togola, T. and McIntosh, S.K. 'The Good Collector and the Premise of Mutual Respect Among Nations' (1995) *African Arts* (Autumn): 60, 67.

[37] Dobinson, C. and Denison, S. *Metal Detecting and Archaeology in England* (English Heritage, London, 1995): xi.

[38] In *United States v. McClain* (545 F.2d 988 (1977) at 1003) the United States Court of Appeals, Fifth Circuit, stated:

> The date of exportation is focused on because illegal exportation constitutes a sufficient act of conversion to be deemed a theft. Of course, owned property may have been illegally taken or converted before exportation, e.g. by discovering and failing to register an artifact or by an unlawful transfer.

Although the court was speaking in the context of the *National Stolen Property Act*, we believe that, as a matter of principle, this should be taken as a general characterization of theft. See further p. 37.

[39] O'Keefe, P.J. 'Provenance and Trade in Cultural Heritage' (1995) *University of British Columbia Law Review* (Special Issue): 259.

[40] 593 F 2d. 658 (1979) at 660.

to have come from an old collection or vault. But apart from circumstantial evidence such as this, there is rarely any scientific method of distinguishing when a particular antiquity was excavated.

Removal from monuments

Many States make it an offence to remove part of a monument. These include existing structures and the remains of structures as well as parts of the landscape which have been altered by the hand of humankind. The monument may be grand or humble. Thus, the *Ancient Monuments and Antiquities Ordinance* of Belize provides that an 'ancient monument' is:

> any structure or building erected by man or any natural feature transformed or worked by man, or the remains or any part thereof, whether upon any land or in any river, stream or watercourse or under the territorial waters of the country, that has been in existence for one hundred years or more.

Whatever its nature, a monument is invariably owned by someone: the removal and taking away of the antiquity constituting theft. The removal also causes damage to the monument itself which in some jurisdictions (for example, France) is a crime carrying severe penalties.[41]

As with excavations, there may be difficulty in establishing that a particular antiquity comes from a monument. To do this there will normally have to be records describing the antiquity in position unless it can be shown that it fits precisely the place from which it was taken. An example is that of the mosaics in the case *Autocephalous Greek-Orthodox Church of Cyprus v. Goldberg & Feldman Fine Arts, Inc.*[42] where there was a textbook describing them and photographs showing them in position in the church of the Panagia Kanakaria.

[41] Saujot, C. 'L'Article 322-2 du Code pénal: une protection renforcée du patrimoine culturel?' (1996) *Ed. du Juris-Classeur* (April):1.

[42] 717 F.Supp. 1374 (1989); 917 F.2d 278 (1990): the case was an action by the Church for return of the mosaics from a dealer in the United States who had bought them in Europe after they had been removed from the church.

Unlawful exports

Export control has an important role to play. For example, as shown later,[43] lack of proper export documentation can have a serious effect on the market value of an antiquity. It may also enable a State to mount an argument for return of antiquities taken through the destruction of a site or a monument. But many States do not provide for the return of an object just because it has been unlawfully exported from the claimant State unless there is an agreement between the States concerned.

It will be seen in the analysis below that existing and contemplated international agreements and arrangements have a chequered history.[44] One is only now in the process of achieving its full potential. Another is too new for its effectiveness to be tested. The other two have yet to be implemented. Nevertheless, the educative effect of these documents should not be discounted. The drafting process – sometimes taking up to ten years or more – and the consequent discussion on whether they should be implemented, raises consciousness of the problem and the possible means of addressing it.

1970 UNESCO Convention

As is well known the major international agreement in this area is the 1970 UNESCO *Convention on the Means of Prohibiting and Preventing the Illicit Import, Export and Transfer of Ownership of Cultural Property*.[45] Antiquities clearly fall within the scope of the Convention. Included in the definition of 'cultural property' are:

> (c) products of archaeological excavations (including regular and clandestine) or of archaeological discoveries;

[43] See p. 28.

[44] It is acknowledged that there are other international agreements and arrangements – for example, the *Convention on the Protection of the Archaeological, Historical, and Artistic Heritage of the American Nations* 1976 and the *European Convention on Offences Relating to Cultural Property* 1985 – but the four analysed in the text are the most recent and important in illustrating the issues involved: for detailed comments on the other agreements and arrangements see O'Keefe, P.J. and Prott, L.V. *Law and the Cultural Heritage: Volume III: Movement* (Butterworths, London, 1989) 667ff.

[45] 823 United Nations Treaty Series 231.

(d) elements of artistic or historical monuments or archaeological sites which have been dismembered;
(e) antiquities more than one hundred years old, such as inscriptions, coins and engraved seals.

This Convention has not yet achieved its full potential although that may now be in sight. As at 31 December 1996 there were 85 States party to the Convention. Until that date only three of these – Australia, Canada, and the United States of America – could be considered 'market' States. However, on 7 January 1997, France ratified the Convention and Switzerland has announced it will also do so. This has given a new impetus to the Convention.

As a result of its drafting history, there are conflicting views as to what the Convention requires of Member States. Some say that the key provision is Article 7 which deals with prohibition of the import of stolen cultural property while others point to Article 3 which refers to the 'illicit' import, export and transfer of ownership of cultural property. The United States of America has followed the first approach – the minimalist approach – while Australia and Canada have taken the broader interpretation of obligations.

One way forward might be for States already party to the Convention to raise it, when appropriate, during bilateral negotiations with States not party. These need not be formal treaty negotiations. The issue could be an appropriate one in the discussions that often take place between States on cultural matters of common interest; on legal matters and on trade topics. The importance of the Convention for protection of the heritage in general, but especially antiquities, could be stressed and the need for a broad interpretation.

UNIDROIT Convention

The UNIDROIT *Convention on Stolen or Illegally Exported Cultural Objects*[46] was adopted at a diplomatic conference in Rome on 23 June 1995. It is too early yet to say how effective this will be. However, it is noteworthy that among the signatories were France, Italy, Netherlands and Switzerland; Canada is seriously considering participation. The Convention demands the return of any stolen cultural object – the definition of which relies on the same categories of cultural property as those set out in the 1970 UNESCO Convention. The return of

[46] Reproduced in (1996) *Uniform Law Review* NS-1: 110.

unlawfully exported cultural objects is mandatory only in specified circumstances. A court of the requested State must establish that:

> ... the removal of the object from its territory significantly impairs one or
> more of the following interests:
> (a) the physical preservation of the object or of its context;
> (b) the integrity of a complex object;
> (c) the preservation of information of, for example, a scientific or
> historical character;
> (d) the traditional or ritual use of the object by a tribal or indigenous
> community,
> or establishes that the object is of significant cultural importance for the
> requesting State.

Antiquities taken from a monument would fall under paragraph (b). Some other categories will fall under (c) or (d) or be considered of significant cultural importance to the requesting State so as to come within the general provision. What may be called ordinary antiquities would fall under (a) if their taking had significantly impaired the context or they could be classified as stolen.[47]

EU Directive

In 1993 European Union Council Directive 93/7/EEC on the return of cultural objects unlawfully removed from the territory of a Member State came into force. To be covered by the Directive cultural objects must be classified by a Member State as 'national treasures possessing artistic, historic or archaeological value' and must fall within one of the categories set out in the Annex to the Directive. This includes:

1. Archaeological objects more than 100 years old which are the products of:
 – land or underwater excavations and finds,
 – archaeological sites,
 – archaeological collections.

2. Elements forming an integral part of artistic, historical or religious monuments which have been dismembered, more than 100 years old.

[47] As they would be if there is state ownership and they come from a clandestine excavation (Article 3(2)): see p. 37.

There are no financial thresholds applicable to these two categories. Antiquities clearly fall within the definitions.

The procedure for return is implemented by the requesting State initiating proceedings in a component court of a State where the unlawfully removed object is found. If the court finds that the object is a 'cultural object' within the meaning of the Directive and that it was unlawfully removed then the court must order its return. After return, ownership of the object is governed by the law of the requesting Member State. Compensation may be payable by the requesting State if the court finds that the 'possessor exercised due care and attention in acquiring the object'.

Member States were required to report on their application of the Directive and the Regulation in February 1996 and a general review of the situation should have been tabled by the end of that year. However, as at March 1997 some States had still to report. Indeed, not all Member States of the Union have passed implementing legislation for the Directive. One (Portugal) argues that this is not necessary under its existing system of law. In addition, there do not appear to have been any judicial proceedings for return of cultural objects under the Directive. This may not be surprising, seeing the time it takes such proceedings to get under way. The reports of States and the review, when these do become available, should provide useful information on the operation of the European system – information significant in terms of the UNIDROIT Convention considering the similarities between the two. (The Directive was based on an early draft of the UNIDROIT Convention.)

Commonwealth Scheme

The Law Ministers of the Commonwealth (formerly British Commonwealth), at their Mauritius meeting in November 1993, adopted a 'Scheme for the Protection of the Material Cultural Heritage'. This is a non-binding arrangement for member countries. A model Bill for implementation of the Scheme was discussed by the Law Ministers of the Commonwealth at their meeting in April 1996 and will be further examined by senior officials in 1988.

At Mauritius, Britain indicated that it could not at present join the Scheme because of difficulties arising from its obligations as a member of the European Union and the placing of bureaucratic burdens on its large art trade. The British Attorney-General stated that Britain welcomed the Scheme; it did not 'close the

door' on eventual participation; and it would give informal support through diplomatic and other channels.

Objects that would be affected by the Scheme are 'all items of cultural heritage so classified by, and subject to export control by, the country of export'. To be of national significance, the item should satisfy certain specified criteria, including therein whether it was of 'archaeological significance'.

The basic thrust of the Scheme is similar to that of the UNIDROIT *Convention on Stolen or Illegally Exported Cultural Objects* 1995. However, the Scheme has somewhat greater flexibility in the procedures that may be adopted in seeking return of an illegally exported item. For example, such an object may be seized by the authorities in the requested State and returned to the requesting State if, within 12 months, no court proceedings have been instituted to determine questions of title and compensation. Alternatively, the requested State may institute proceedings or advise the requesting State to do so. If the court orders the object returned, the Scheme requires a determination on compensation payable to the holder. All other questions of title and compensation are to be determined by proceedings in the requesting State.

Practical problems of recovery

It must be realized that, in practice, recovery of an antiquity that has been unlawfully exported or stolen and taken outside the country is really only feasible when it is of considerable value. For minor antiquities – such as those attractive as decorative art – the financial implications of seeking recovery are such that normally an owner would not pursue it even as a way of making a point.

The cost is often considerable. While a wealthy developed State might be able to find the money, for many poorer States this may be well be impossible without sacrificing programmes directed to the physical wellbeing of their citizens. For a private owner the costs of recovery do not often even allow it as an option.

The first problem may be to find the missing antiquity. For example, an English farmer, Browning, for many years has maintained that a group of bronzes – the Icklingham Bronzes – were illegally removed from a site on his farm and smuggled abroad. He eventually found them in the collection of Levy and White – collectors of antiquities in New York. In 1993 he reached an agreement with Levy and White that on their death the Bronzes would be bequeathed to the

British Museum. Browning is reported to have spent over £100,000 on his efforts to recover them.[48]

When the whereabouts of the antiquity is established, a court case may be necessary, particularly if the allegations of theft or unlawful export are disputed or there has been an intervening transaction which raises questions of ownership. Money will be needed to pay for legal representation. The claimant may be required to post a bond to cover the costs of the other side if it loses the case. It will probably be necessary to pay the costs of witnesses who have to be transported to the court. There will be costs for storage of the antiquity in appropriate conditions and possibly payment of experts for identification and authentication. Claimants cannot normally expect that the State where the proceedings are taking place will be able or willing to finance these matters.

Even in situations where the claimant succeeds in recovering the antiquity, there may be difficulty in recovering its costs. In the case *Bumper Development Corp.* v. *Commissioner of Police for the Metropolis and others*,[49] the Government of India and others sought the return of a Shiva Nataraja from a Canadian corporation which had bought the bronze in London. The bronze had been seized by the police while undergoing conservation treatment at the British Museum. The English courts ordered its return to India and awarded the plaintiffs, jointly and severally, costs which, in February 1994, were fixed at £303,489.67 plus interest. In April that year, India sued Bumper Development Corporation in its home province of Alberta to enforce the English award. On 19 April 1995, the Alberta Court of Queen's Bench granted summary judgment enforcing the English judgment for costs and damages against Bumper. The Court of Appeal of Alberta dismissed an appeal by Bumper which is applying for leave to appeal to the Supreme Court of Canada.[50]

There are many other considerations apart from cost. The claimant will have to prepare evidence as to the origin of the antiquity at issue and the circumstances in which it left the country. Witnesses will have to be found. Legislation

[48] Palmer, N. 'Recovering Stolen Art' in Tubb: fn. 12, 1, 14.

[49] [1991] 4 All E.R. 638.

[50] Paterson, R.K. 'The "Curse of the London Nataraja"' in *Legal Affairs and Management Symposium, 1–2 March 1996, Ottawa* (Canadian Museums Association, Ottawa, 1996) 251; Rolf, D.C. 'The Union of India v. Bumper Development Corporation: A Canadian's International Art Litigation Experience' in *Legal Affairs and Management Symposium, 1–2 March 1996, Ottawa* (Canadian Museums Association, Ottawa, 1996) 266; Paterson, R.K. 'The Curse of the London Nataraja' (1996) *International Journal of Cultural Property 5*: 330.

will need to be examined. Overlying all of this are often significant problems of language and cultural values for the claimant in understanding a foreign legal system and bureaucracy.[51]

Effect on value

While it may be difficult to actually recover an antiquity that has been unlawfully exported there is evidence that the absence of an export licence or permit can have an affect on its market value. An opinion to this end was expressed in evidence in the case *Jeanneret* v. *Vichey*[52] in the United States of America. It concerned the alleged unlawful export of a painting from Italy to Switzerland from whence it was taken to the United States. It was later sold to a dealer, Jeanneret, who, when she learnt of the problems concerning its export, alleged that, as a professional art dealer, she could not 'sell it anymore nor show it'.[53] In an action seeking annulment of the contract whereby she had acquired the painting, the following evidence was given:

> John Tancock, a vice-president of Sotheby Parke Bernet auction house and head of its Department of Impressionist and Modern Painting and Sculpture, testified that, but for the question of illegal exportation, he would appraise the painting at $750,000. On the other hand, if the painting lacked 'the necessary export documents from any country where it had been located', his opinion was that it would be impossible to sell the painting since '[n]o reputable auction house or dealer would be prepared to handle it'. Hence, 'on the legitimate market its value is zero'. He would date the painting 'early 1920's, 1919, 1922, something like that'. Nancy Schwartz, an art dealer associated with the Spencer Samuels & Company gallery in New York, testified that the gallery having received a number of requests for paintings by Matisse, she communicated with Mme. Jeanneret on May 1, 1975 that she would not be able to sell the painting as plaintiff had proposed to her in Geneva in February: 'I had a client who was ready to buy it, but as you said that the painting left Italy clandestinely I realized that this painting

[51] Appendix I contains some recent comments by a senior Canadian official with many years experience in implementing the legislation of that country and in seeking to facilitate the recovery of antiquities by foreign States.

[52] 541 F.Supp. 80, *rev'd. & remanded* 693 F.2d 259 (1982).

[53] 693 F.2d 259 at 261.

cannot be sold'. Graham Leader, an independent art dealer, identified letters he had written to Mme. Jeanneret from London in June and November 1974. In the former he stated that he expected a client in the next few days to whom he had indicated a price of 1,100,000 Swiss francs for the painting; in the latter he confirmed a telephone conversation announcing his refusal to consider handling the painting or advising one of his best clients to buy it 'from the moment that I learned that the painting had been clandestinely exported from Italy by its former owner, Mme. Vichey-Frua DeAngeli and that it could thus be subject to suit by any authority.'[54]

Another case in similar vein is Kingdom of *Spain* v. *Christie, Manson & Woods Ltd.*[55] concerning a Goya painting exported from Spain and eventually offered for sale at Christie's in London. The Spanish Government sought declarations from the English courts that three documents purporting to be Spanish export documents were false and that the painting had been exported illegally. In the course of his judgment, Sir Nicolas Browne-Wilkinson V.-C. commented:

> …although there is no direct evidence of the fact, the very existence of the dispute and the positions taken up by the parties suggests that if the picture were illicitly exported its open market value is likely to be less than if it were legally exported.[56]

Although the above two instances both concerned the unlawful export of paintings, the same principles would apply to antiquities. Their attractiveness to potential buyers is lessened if there is the possibility of legal action arising from unlawful export. A further factor is that many museums and art galleries have stated that they will not purchase, or accept as donations, items of the cultural heritage which do not have an acceptable provenance.[57] Persons who buy antiquities with the intention of so donating them thus have the incentive removed and will be less interested in purchasing an antiquity with such a defect in its provenance.

[54] Fn. 53, 263.

[55] [1986] 1 W.L.R. 1120.

[56] Fn. 55, 1125.

[57] See p. 44.

Unintended effect

The main purpose of controls on export is to prevent certain objects from leaving a country when this would adversely affect its cultural heritage. However, there can be unintended consequences with persons attempting to use these controls to create a false provenance. For example, the export of antiquities from the United Kingdom requires a licence if certain criteria are met. In 1992, the Reviewing Committee on the Export of Works of Art stated:

> There have been cases where licences have been applied for the export of objects (mostly antiquities) which have probably not been within the UK for 50 years and which may, quite possibly, have been illegally exported from their country of origin. UK export licences are then unjustifiably used as evidence that the objects in question were legitimately on the market in the first place. This practice is, of course, wholly unacceptable.[58]

Where an export licence is required, under the United Kingdom system, the application is assessed against what are known as the Waverley Criteria and, if one of these is satisfied, the licence may be deferred – usually for a limited period of time.[59] Cook describes how this procedure could be used to create a provenance.

> One case... concerned an Etruscan helmet that I had to refer to the Reviewing Committee because it was evidently of high quality and because on enquiry the auctioneer insisted that it had been consigned for sale from within the United Kingdom. Evidence was eventually forthcoming that it had been smuggled out of Spain quite recently, and a licence to re-export could not therefore be withheld. The Reviewing Committee was understandably displeased: 'We cannot allow our procedures to be used as a camouflage to give a spurious provenance to smuggled objects. In future, therefore, when the Expert Adviser has strong doubts as to the date at which an object has been brought into this country, we shall recommend that a licence should be granted even if the object is of Waverley standard'.[60]

[58] Reviewing Committee *Export of Works of Art 1991–2. Thirty-eighth Report of the Reviewing Committee* (HMSO, London, 1992): 4.

[59] Maurice, C. and Turnor, R. 'The Export Licensing Rules in the United Kingdom and the Waverley Criteria' (1992) *International Journal of Cultural Property* 1: 273.

[60] Cook, B.F. 'The Trade in Antiquities: A Curator's View' in Tubb: fn. 12, 181, 187.

In other words, no judgment will be given by the Committee on the object's value and, no doubt, the suspect origin of the object will be mentioned.

Acquisitions
There have been some moves by States to control the acquisition of cultural heritage, including antiquities, by such means as registration of collectors, licensing of dealers, requiring notification of suspect offers and annulling sales.

Registration of collectors
In New Zealand, only registered collectors may acquire an artifact and it is an offence to acquire an artifact if not registered.[61] Under Greek legislation, any person who wishes to make a private collection of antiquities, by purchasing them in Greece or abroad, must ask permission from the State authorities.[62] So far this approach has not been extensively developed among States. However, it does offer another way in which controls could lessen destruction and theft if the authorities have the power to check the sources of the antiquities.

Licensing dealers
Regulation of dealers and their acquisition of antiquities is used as a control mechanism in some States. Usually this is done through a system of licensing. A licensed dealer may be required to keep a register of his or her transactions. Article 10 of the UNESCO *Convention on the Means of Prohibiting and Preventing the Illicit Import, Export and Transfer of Ownership of Cultural Property* 1970 specifies that States Party undertake, as appropriate for each country, to

> oblige antique dealers, subject to penal or administrative sanctions, to maintain a register recording the origin of each item of cultural property, names and addresses of the supplier, description and price of each item sold and to inform the purchaser of the cultural property of the export prohibition to which such property may be subject.

Theoretically the register would allow acquisitions of antiquities to be traced and should dissuade dealers from acquiring those with dubious provenance. In

[61] *Antiquities Act* 1975, s.14.

[62] See further O'Keefe and Prott, fn. 44, 109.

practice it is questionable just how effective this is. Register entries may be falsified; descriptions may be so broad as to be useless; lack of regular checks may negate its use. In sum, regulation of dealers can be an effective control but only if it is properly designed and efficiently supervised.

Notifying suspect offers

The *European Convention on the Protection of the Archaeological Heritage (Revised)* 1992[63] came into force on 25 May 1995. On becoming party to the Convention, States are obliged to denounce the original of 1969. As of 27 January 1997 the following eleven States were party: Bulgaria, Estonia, Finland, France, Hungary, Liechtenstein, Malta, Norway, Poland, Sweden, Switzerland.

The aim of this Convention is to establish a minimum standard for the management of the European archaeological heritage. Article 10 provides for some controls on acquisitions of antiquities.[64] For example, any offer 'suspected of coming either from illicit excavations or unlawfully from official excavations' that comes to the attention of a State Party must be notified to the 'competent authorities in the State of origin which is a Party to this Convention'. States must take whatever steps are necessary to ensure that all museums and similar institutions whose acquisition policy is under their control 'do not acquire elements of the archaeological heritage suspected of coming from uncontrolled finds or illicit excavations or unlawfully from official excavations'. Museums and similar institutions whose acquisition policy is not under State control are to be sent a copy of the Convention and every effort made to try and ensure that they follow suit.

Annulling sales

The Council of Europe has also been preparing a *Draft Recommendation on Measures to Promote the Integrated Conservation of Historic Complexes and Their Movable Heritage* [HCMH]. The current Draft defines these terms to include buildings and structures of historical and archaeological interest 'including its movable heritage, whether situated inside or outside' when: it is

[63] European Treaty Series No. 143.

[64] Because the issues involved in unlawful trade and acquisition of cultural heritage are so complex it was not thought desirable for there to be more detailed treatment in a Convention designed for another purpose.

physically attached to the building; forms part of the building for historical or archaeological reasons and cannot be separated without damaging the structure or unity of the complex; is conserved *in situ* and forms an integral part of the complex for historical or archaeological reasons.

The current Draft provides that a transfer of an integral part unlawfully separated from a protected HCMH should be considered null and void. This would then give rise to an appropriate procedure under the laws in force in each country. Moreover, the person responsible for the separation 'should be subject to a major sanction as defined by each country's legislation'. It would be no defence to plead ignorance of the protected nature of the HCMH.

Identification problems

One of the major problems in seeking return of an antiquity that is alleged to have been unlawfully exported is identification – it is essential to prove that the antiquity in question is the same as the one taken from the claimant State. Where the antiquity came from a clandestine excavation this is particularly difficult to do. A claim by Turkey against the Metropolitan Museum in New York to recover artifacts alleged to have come from burial mounds in the Usak region in 1966 succeeded in 1992 because a fragment of a wall painting fitted a gap in a painted wall in one of the named burial mounds.[65] The Maori carving at issue in *Attorney-General of New Zealand v. Ortiz* [66] could be identified because it was struck by the spade of the person who excavated it and a piece of wood gouged out; photographs taken of the carving in New Zealand showed the mark which was identical to that on the carving put up for auction in London. However, unless there are peculiar circumstances such as those illustrated, identification will be difficult if not impossible. This was one of the difficulties facing claimants to the silver platters and other vessels know as the 'Sevso Treasure': none of them could prove conclusively that it was from within their territory that the antiquities came.[67]

[65] Lowenthal, C. 'Critical Comments on the Draft Principles for a Licit Trade in Cultural Property' in Briat, M. and Freedberg, J.A. *Legal Aspects of International Trade in Art* (ICC Publishing, Paris; Kluwer, The Hague; 1996): 129, 130.

[66] [1982] 2 W.L.R. 10; [1982] 3 W.L.R. 570; [1983] 2 W.L.R. 809.

[67] For background on this episode see D'Arcy, D. 'The Sevso Melodrama: Who Did What and to Whom', *The Art Newspaper*, No. 31, October 1993: 14.

State ownership

As part of their protective regime, a number of States claim ownership of all or certain categories of antiquities. Such a claim allows legal proceedings to be taken in foreign courts for the recovery of antiquities unlawfully excavated and/ or exported. The possibility of a claim being made would, in theory, inhibit purchases of antiquities without adequate provenance and thus reduce destruction of the sources of such antiquities. But much depends on how effective the claim is likely to be.

State practice

The Malaysian *Antiquities Act* 1976 states (s.3):

> (1) Subject to the provisions of this Act, every antiquity discovered in West Malaysia on or after the date of the coming into force of this Act shall be the absolute property of the Government.

> (2) Every ancient monument which on the date of the coming into force of this Act is not owned by any person or the control of which is not vested in any person as a trustee or manager, shall be deemed to be the absolute property of the Government.

> (3) All undiscovered antiquities (other than ancient monuments), whether lying on or hidden beneath the surface of the ground or in any river or lake or in the sea, shall be deemed to be the absolute property of the Government.

Similar is the *Antiquities Law* of Cyprus:

> Subject to the provisions of this Law, all antiquities lying undiscovered at the date of the coming into operation of this Law in or upon any land shall be the property of the Government.

In New Zealand the claim of State ownership is restricted to objects of Maori or other non-European origin made or brought to New Zealand prior to 1902.[68] English law dating back hundreds of years gives title to treasure trove to the

[68] *Antiquities Act* 1975, s. 11.

Crown. To constitute treasure trove, an object must be of gold or silver;[69] someone must have concealed it with the intention of subsequently returning for it; the original owner or those with a title deriving from him must be unknown.[70] Ancient Scottish law reserves to the Crown a wide range of undiscovered antiquities.[71]

When the 1956 UNESCO *Recommendation on international principles applicable to archaeological excavations* was being negotiated, agreement could not be reached on whether it should recommend that States take ownership of undiscovered antiquities. The compromise formula adopted requires each Member State to ensure the protection of its archaeological heritage, in particular by defining:

> ... the legal status of the archaeological sub-soil and, where State ownership of the said sub-soil is recognized, specifically mention the fact in its legislation.

Ownership of antiquities was thus left to the discretion of each State.

However, by 1995 there was greater consensus. On the initiative of the United States delegation, a provision (Article 3(2)) was added to the UNIDROIT *Convention on Stolen or Illegally Exported Cultural Objects* stating:

> For the purposes of this Convention, a cultural object which has been unlawfully excavated or lawfully excavated but unlawfully retained shall be considered stolen, when consistent with the law of the State where the excavation took place.

This appears to mean that, where a State has legislation declaring its ownership of undiscovered antiquities, if they are excavated without permission, they shall be considered stolen. Moreover, they are to be regarded as stolen when they are lawfully excavated but not disclosed to the appropriate authority as, for example, where an antiquity is found during ploughing by a farmer who sells it to a

[69] *AG of the Duchy of Lancaster v. G.E. Overton (Farms) Ltd.* [1982] Ch. 277.

[70] Because of difficulties in applying these principles, together with the limited coverage of treasure trove, new legislation is in the process of being introduced in England although state ownership of certain categories of antiquities will be maintained; the legislation has passed Parliament but will not come into force until a Code of Practice has been adopted.

[71] Sheridan, A. 'Portable Antiquities Legislation in Scotland: What is It, and How Does It Work?' in Tubb: fn. 12, 193.

dealer without making the necessary notification. State ownership of antiquities previously undiscovered thus cannot be regarded as an aberration. Indeed, it has recently been expressed as a positive duty on the part of a State.

A State duty?

It would, I think, now be universally accepted, certainly by the People of Ireland, and by the people of most modern States, that one of the most important national assets belonging to the people is their heritage and knowledge of its true origins and the buildings and objects which constitute keys to their ancient history. If this be so, then it would appear to me to follow that a necessary ingredient of sovereignty in a modern State and certainly in this State, having regard to the terms of the Constitution, with its emphasis on its historical origins and a constant concern for the common good is and should be an ownership by the State of objects which constitute antiquities of importance which are discovered and which have no known owner. It would appear to me to be inconsistent with the framework of the society sought to be protected by the Constitution that such objects should become the exclusive property of those who by chance may find them.

These words appear in the judgment of Finlay, Chief Justice of the Supreme Court of Ireland, in the case *Webb* v. *Ireland*.[72] Four other judges of the Supreme Court concurred, two of them explicitly. For example, Walsh J. said:

I fully agree with the view expressed by the Chief Justice that it would now be universally accepted by the people of Ireland that one of the most important national assets belonging to the People is their heritage and the knowledge of its true origins, and the buildings and objects which constitute the keys to their ancient history. I also agree with him in his statement that it is a necessary ingredient of the sovereignty of a modern state, and for the reasons he gives, that is for the common good that there should be ownership in the State of all objects which constitute antiquities of importance and which are discovered to have no known owner.[73]

[72] (1988) *Irish Law Reports Monthly* 8: 565, 594. This case did not involve interpretation of legislation but rather application of common law principles of ownership.

[73] At 601.

These statements were further endorsed by Barr J. of the High Court of Admiralty of Ireland in *King & Chapman* v. *The Owners and All Persons Claiming an Interest in the 'La Lavia', 'Juliana' and 'Santa Maria de la Vision'*.[74] The President of the Italian Republic has publicly expressed similar views:

> A country with a rich sub-soil is likely to have archaeological remains worthy of excavation and endeavours to defend them. It has not so much the right to defend them as the duty to defend them![75]

If, as it appears, there is an emerging duty[76] on the part of States to take ownership of undiscovered antiquities, it would follow that other States should enforce those ownership rights in respect of an antiquity that appears in their jurisdiction.

Criminal proceedings

State ownership allows for the institution of such proceedings. As shown above, the UNIDROIT *Convention on Stolen or Illegally Exported Cultural Objects* regards antiquities taken when there is State ownership as stolen. Palmer states explicitly that the taking of treasure trove under English law is theft.

> Treasure trove belongs to the Crown. Objects which satisfy the legal definition of treasure trove are the property of the Crown or its franchisee. To remove treasure trove with the intention of permanently depriving the Crown or its franchisee of it constitutes the crime of theft and presumably (although there is no authority on the point) the tort of conversion.[77]

It is probable that a British court would similarly classify an antiquity taken from a foreign country with an ownership statute. In the United States the *National Stolen Property Act* prohibits the transportation 'in interstate or foreign com-

[74] Unreported judgment of 26 July 1994.

[75] Audience given 9 June 1995 to Heads of Delegations attending the UNIDROIT Diplomatic Conference: UNIDROIT *Diplomatic Conference for the Adoption of the Draft UNIDROIT Convention on the International Return of Stolen or Illegally Exported Cultural Objects, Acts and Proceedings*: xvii.

[76] By way of analogy, ownership claims over natural resources are made by many States and this practice has been endorsed by the international community: O'Keefe, P.J. 'The United Nations and Permanent Sovereignty over Natural Resources' (1974) *Journal of World Trade Law* 8: 239–82.

[77] Palmer, N.E. 'Treasure Trove and Title to Discovered Antiquities' (1993) *International Journal of Cultural Property* 2: 275, 277.

merce [of] any goods, ... of the value of $5,000 or more' with knowledge that such goods were 'stolen, converted or taken by fraud'. The major case where this statute was relied on is *United States* v. *McClain*[78] where the court held that an antiquity would be regarded as stolen property under the Act if it were taken from a foreign State which had declared its ownership and it could be proven that the antiquity fell within the terms of the declaration.

Civil proceedings

But probably more important than possible criminal proceedings, is the right that State ownership gives to take civil proceedings for recovery of an antiquity.

> Where... buried artefacts are excavated and sold outside England, their identity as treasure trove can materially affect both the acquirer's title and the original owner's ability to retrieve them... the advantage which treasure trove possesses over the ordinary title to discovered objects asserted by landowners (or finders) is that the title which it confers is independent of any specific locus. Treasure trove is Crown property irrespective of the place in which it is found. In the absence, therefore, of some overseas disposition which is capable of extinguishing pre-existing title under the law of the country where the goods are situated at the time, the Crown's retrieval of its property may be a relatively simple matter. Where, on the other hand, discovered antiquities are demonstrably not treasure trove (as where they are made of bronze rather than of gold or silver) a land-owner who seeks to recover them from an overseas buyer faces the immediate difficulty of proving that they came from his land.[79]

Ecuador took civil action in the Italian courts to recover some 12,000 archaeo-logical objects taken from Ecuador and confiscated from their holder by authori-ties in Turin.[80] After examining the legal provisions of Ecuador relating to archaeological objects, the court held that they fell into 'an intermediate cat-egory between private property and the property owned by a nation for public purposes'. They were part of the eminent domain of the State, which was characterized by the inherent sovereign power of the State to exercise protec-

[78] 545 F.2d 988 (5th Cir. 1977), subsequent opinion at 593 F.2d 658 (5th Cir. 1979), *cert. denied*, 444 U.S. 918 (1979).

[79] Palmer, fn. 77, 276–77.

[80] *Republic of Ecuador v. Danusso* District Court of Turin 593/82.

tive powers over the property and which was distinct from both private property and public property.[81] This power of the State is inalienable and indefeasible. While the right of the private citizen over such property is recognized, it is irreversibly affected by the eminent domain of the State, in whose protection this category of property is placed, in the interest of and for the benefit of the community. The practical effect of the provisions of Ecuadorian law applying to such property was the prohibition of free trade in it, limits as to the acquisition of such property by a private person, and the prohibition of export.

Restrictive interpretation

But it must not be thought that all courts are as sophisticated in their reasoning as the Italian court mentioned above. A significant case in the United States for recovery of antiquities alleged to have been taken from a foreign State claiming ownership under general law is *Government of Peru* v. *Johnson*.[82] There the Court stated:

> …the law of June 13, 1929, does proclaim that artifacts in historical monuments are 'the property of the State' and that unregistered artifacts 'shall be considered to be the property of the State'. Nonetheless, the domestic effect of such a pronouncement appears to be extremely limited. Possession of the artifacts is allowed to remain in private hands, and such objects may be transferred by gift or bequest or intestate succession. There is no indication in the record that Peru ever has sought to exercise its ownership rights in such property, so long as there is no removal from that country. The laws of Peru concerning its artifacts could reasonably be considered to have no more effect than export restrictions…[83]

It must be said that in making this characterization the court is trespassing into dangerous fields. Where is the dividing line? Once one departs from the classification used by the country from which the object was taken it opens the door to increasingly idiosyncratic conclusions by the foreign court.

[81] This translation of the words 'dominio eminente' is to be kept entirely distinct from the concept of 'eminent domain' in legal usage in England and United States of America.

[82] 720 F. Supp. 810 (1989).

[83] Fn. 82, 814. Peru failed in its suit mainly on other grounds e.g. it failed to satisfy the Court that the objects in question came from its territory and it could not prove that they had been exported at a time when the State ownership legislation was in force.

For State ownership of undiscovered antiquities to provide effective protection against theft and clandestine excavation, the State should have clear and effective laws on the matter. It is likely that foreign courts will be assailed by arguments from possessors assiduous to find any imperfections and use them to deny recognition to the State's title. The characterization of the Peruvian law adopted by a court in the United States of American has already been seen. A recent commentary on that law further notes its imperfections:

> Legislative attempts to establish State ownership over cultural property proved to be impracticable due to the lack of material resources to establish a registry and the juridical problems as well as constitutional and legal violations said legislation brought with it.[84]

Yet another instance of restrictive interpretation is a case which was before the Swiss courts a couple of years ago. It concerned five tombstones from the period AD 200–300 and allegedly from Turkey. Evidence was given by a Swiss professor that he saw two of them in a rural village in Turkey in 1973 after recent excavation by the villagers. He informed the Turkish authorities but there was no evidence that they did anything. He next saw the tombstones in the Antikenmuseum Basle. The Turkish authorities then claimed them. The applicable Turkish law of 1973 stated:

> All kinds of monuments and antiquities, moveable and immovable, known to exist or which may be discovered in the future, on land and property belonging to the State and on property and land owned by private or legal persons, belong to the State.

The Basle trial court held

> …as a matter of law that under the Turkish law applicable in 1973 and before, which had changed in 1906 and 1926 (and had changed once again in 1983), there was no ipso iure acquisition by the Turkish state. Since the Turkish state had not shown any interest in the tombstones once it had been notified of their existence it did not acquire title in them at that time.[85]

[84] Batievsky, J. 'The Protection of Pre-hispanic Cultural Property in Peru' paper presented at 12th Section on Business Law Biennial Conference, International Bar Association, Paris, 17-22 September 1995: 6.

[85] Karrer, P.A. 'Sale of Art in Switzerland' paper presented at 12th Section on Business Law Biennial Conference, International Bar Association, Paris, 17–22 September 1995: 11.

Whether title vests in the State directly by statute or requires in addition some other physical act is regulated differently in different countries. While the decision may be true of Swiss law, is it necessarily accurate for Turkey? The same issue has created difficulties for judges in the United States of America interpreting Mexican law[86] and for the English House of Lords interpreting New Zealand law.[87] In both situations, it seems likely that the interpretation of the foreign law taken by the court would not have been that of a court in the foreign jurisdiction.

Disputing State ownership

It must also be recognized that a State declaration of ownership can be relatively easily defeated by knowledgeable criminals holding antiquities of such value as to make it worth their while to 'launder' them. For example, many States have a legal system incorporating the *bona fide* purchaser rule i.e. if an object, even one that has been stolen, is purchased by a person who buys it without knowledge of any defect in the seller's title, the purchaser will acquire good title after a specified period of time. The onus is usually on the person making the claim to prove that the purchaser was *not bona fide*. This is very difficult to do if the parties have been careful to hide their tracks. So hard is it that a senior British police official once expressed the jaundiced view that such purchasers are all in good faith.[88]

State claims may also be defeated by legal rules specifying that after a certain period of time no legal proceedings may be commenced to recover an object i.e. what is known as limitation of action rules. In England, where the ancient rule is that a thief cannot pass good title to anyone, the effect of the *Limitation Act* 1980 is that, if there is a theft followed by 'conversion' (i.e. if the goods are bought by an innocent purchaser), after six years from the date of that conversion any action by the original owner is barred.[89]

[86] For analysis see O'Keefe and Prott, fn. 44, 374.

[87] Fn. 44, 625.

[88] Ellis, R. 'The Antiquities Trade: A Police Perspective' in Tubb: fn. 12, 222, 223.

[89] Redmond-Cooper, R. 'Limitation Periods in Art Disputes' in Institute of Art and Law (ed.) *Title and Time in Art and Antiquity Claims* (Institute of Art and Law, Leicester, 1995).

Disclosure of finds

There may be an unintended side effect of State ownership claims. Allegations are made that finders fail to disclose their discoveries if they know the State will take them and that this has a deleterious effect on study of the past.

> The present laws in Italy relating to archaeology are a major obstacle to the development of maiolica studies... this kind of work is normally much hampered , says Mr. Mallet, by the fact that many finds, even of sherds with no market value, are concealed for fear that they will be confiscated by the authorities, the law decreeing that all archaeological finds belong to the State... The pity is that, again for legal, and also for fiscal reasons, the highly important collections of maiolica formed by Italians in recent years have not contributed at all to the study of the subject. Collectors are so afraid of showing their pieces to scholars, particularly from the museums, in case they get listed and thus can no longer be freely sold, that they often keep them in bank vaults in Switzerland.[90]

This state of affairs should not be blamed on the concept of state ownership *per se*. Even though the State claims ownership of all undiscovered antiquities this should not necessarily mean that it takes them all when they are found. Those that are not needed for a representative collection could be returned to the finder. For example, the Malaysian *Antiquities Act* referred to at the beginning of this section provides (s.5):

> In any case the Director-General may decide not to retain such antiquity and the same shall then be returned to the person who delivered up possession thereof to the District Officer and thereupon the property in such antiquity shall be deemed to have been transferred to the person...

For those that are kept, a reward may be payable or there may be an agreement to share the antiquity.

Dealer reaction

Many dealers complain of State claims of ownership. Some say that it creates confusion in the marketplace. But knowledge of how the international legal

[90] Cocks, A.G.S. 'Italy's Laws Hold Up Ceramics Scholarship' The *Art Newspaper,* No. 54, December 1995: 11.

system works is often lacking, occasionally leading to a certain arrogance towards other countries. For example, a dealer in the United States of America, one Emmerich, once wrote to the *Washington Post* in these terms:

> Why should we then apply the foreign term 'stolen' to property which may be considered stolen under a legal principle in a foreign country but which is clearly the land owner's, and therefore the original seller's, right to own and sell as he pleases under US law and tradition.[91]

More direct was the *amicus curiae* brief submitted by the American Association of Dealers in Ancient, Oriental and Primitive Art in the case of *United States* v. *McClain*.[92] There the Association argued that if the State claim by Mexico were to give rise to an action under the *National Stolen Property Act* in the United States 'the livelihood of the members of the association will be drastically affected'.[93]

In the end it comes back to a question of provenance. Dealers, auction houses and collectors will be protected if provenance is adequately investigated. This does not necessarily mean tracing the history of an antiquity back to the moment of its discovery – something which is in many instances impossible. A date can be set from which provenance must be established for all, or certain classes, of antiquities.[94]

Summation

It is perfectly proper for States to make these claims and there appears to be a developing recognition of a State's duty to do so. Much of the criticism results from States which pass ownership legislation but then do nothing further. While there is nothing wrong legally with this approach, it is very bad public relations and may lead courts in other jurisdictions to be overly concerned to avoid enforcing State ownership. The law must be expressed absolutely unambigu-

[91] Reproduced in Merryman, J.H. and Elsen, A.E. *Law, Ethics, and the Visual Arts* (University of Pennsylvania Press, Philadelphia, 1987) I: 73.

[92] See p. 38.

[93] Reproduced in Greenfield, J. *The Return of Cultural Treasures* (Cambridge University Press, Cambridge, 1989): 198.

[94] See p. 64.

ously to have a chance of being enforced in another State. Moreover, dilatory enforcement or implementation of the law by local officials, corruption and a generalized attitude of evasion all tend to weaken claims of ownership of undiscovered antiquities as an element of State control. Even when none of this applies, in certain States a claim of State ownership may be defeated by the laundering of the antiquity in another State; by limitation of action rules or by the difficulty of proving the identity of the piece.

Standards of behaviour

The last few decades have seen many groups affected by the trade in antiquities adopt sets of rules designed to establish standards of behaviour for members. These include not only dealers and auction houses but also collecting institutions such as museums and other professionals such as archaeologists. The documents may be called codes of conduct or ethics, policy statements and other names. They may have legal effect but generally this is not their purpose. That purpose is to provide guidance to their members on the minimum standard they should observe in operating their business or carrying on their profession. They also play an educative role – not only for members of the organization but for those outside it. They tell the public what is to be expected of the members in dealings with antiquities – a further educative effect.

Collectors

There appears to be only one association of private individual collectors – the Swiss Association of Collectors. It has no code of conduct.

The premier international organization concerned with museums is the International Council of Museums (ICOM). In 1986 this body adopted a *Code of Professional Ethics* which 'provides a general statement of professional ethics, respect for which is regarded as a minimum requirement to practise as a member of the museum profession'.

Under this Code each 'museum should adopt and publish a written statement of its collecting policy' (Article 3.1). The Code's provision on what it calls 'unlawfully traded material' is particularly strong (Article 3.2) and deserves to be quoted in full.

> The illicit trade in objects destined for public and private collections encourages the destruction of historic sites… theft at both national and

international levels, ... and contravenes the spirit of national and international patrimony. Museums should recognize the relationship between the market-place and the initial and often destructive taking of an object for the commercial market, and must recognize that it is highly unethical for a museum to support in any way, whether directly or indirectly, that illicit market.

A museum should not acquire, whether by purchase, gift, bequest or exchange, any object unless the governing body and responsible officer are satisfied that the museum can acquire a valid title to the specimen or object in question and that in particular it has not been acquired in, or exported from, its country of origin and/or any intermediate country in which it may have been legally owned (including the museum's own country), in violation of that country's laws.

. . .

So far as excavated material is concerned, in addition to the safeguards set out above, the museum should not acquire by purchase objects in any case where the governing body or responsible officer has reasonable cause to believe that their recovery involved the recent unscientific or intentional destruction or damage of ancient monuments or archaeological sites, or involved a failure to disclose the finds to the owner or occupier of the land, or to the proper legal or governmental authorities.

If appropriate and feasible, the same tests as are outlined in the above... paragraphs should be applied in determining whether or not to accept loans for exhibition or other purposes.

Many museums have adopted their own acquisition policies. The phrasing varies considerably but the general tenor is that they abjure the collection of unlawfully traded material.[95]

Since many persons collect with the notion of eventually donating the objects to a museum – or perhaps founding their own – these self-denying policies should have a significant effect on the market. However, many museums are not members of ICOM. Some museums do not appear to have, or at least do not follow, an acquisitions policy of the type discussed.

[95] O'Keefe and Prott, fn. 44, 124ff.

Photographs of apparently stolen *tau tau* and a carved tomb door appear in an exhibition catalogue published by the Museum of Cultural History at the University of California at Los Angeles (1985)... The objects, which were included in the museum's exhibit, are said by villagers to have been procured by a dealer in primitive antiquities directly from an Ulusalu village in 1971. Not only are *in situ* photographs and ownership of the items linked to the same individual, but Ulusalu villagers identified both the object in the book and the dealer in interviews in July 1985.[96]

The Cleveland Museum of Art, the Dallas Museum of Art, and the New Orleans Museum of Art have all recently added Nok pieces to their holdings. The Kimball Art Museum in Fort Worth has just acquired perhaps the rarest of the rare, an Ife terracotta. It should be emphasized that none of these acquisitions are in violation of US law... One does wonder where these acquisitions fit in relation to the mandates and policies of the American Association of Museums and the Association of Art Museum Directors, both of which discourage the unethical trade in antiquities.[97]

Perhaps certain museums are becoming complacent in their acquisition or display of objects – the thrill of 'the chase, the capture' overcoming ethical considerations. Constant scrutiny and publicity is necessary to combat this. For example, ICOM has had occasion to remind a number of museums of the principles of the Code.[98]

Professionals

Many professionals are concerned about the role they play in relation to the trade in antiquities.[99] In particular, they do not wish to be seen as assisting in any way the destruction of the sources of antiquities or theft from collections. Authentication of antiquities is one way in which this could come about. Here

[96] Crystal, fn. 30, 36.

[97] Ross, D.H. 'Disturbing History: Protecting Mali's Cultural Heritage' (1995) *African Arts* (Autumn): 1, 9.

[98] Portes, E. des, 'ICOM and the Battle Against Illicit Traffic of Cultural Property' (1996) *Museum International* 48: 51, 53.

[99] For example, a symposium on the looted antiquities of Iraq, held in Baghdad, December 1994, was attended by archaeologists, art historians, philologists, architects, scientists and police. The Code of Ethics for Professionals Concerned With the Antiquities of the Near and Middle East adopted by the Symposium is set out in Appendix V.

professionals in one discipline may need to be sensitized to the damage they are causing. For example, after considerable persuasion the Research Laboratory for Archaeology and the History of Art at Oxford University agreed to stop dating/ authentication of fired clay artifacts of West African origin for private individuals, salesrooms or commercial galleries.[100]

At the same time, withdrawal from the marketplace creates ethical problems of its own, particularly where previously unknown objects are involved.

> Many of us in the archaeological profession have some small place in that trade, as consultant, as confidant or as 'ancient art adviser'. Few of us will distance ourselves entirely. Faced with some new delight, 'said to be' from somewhere or other outside immediate chance of a legal seizure, we take it into the scholarly world, not comfortably perhaps, but feeling this thing of beauty is so fine, so precious, so important, so rich a potential source of knowledge that no benefit comes to scholarship from pretending it does not exist.[101]

Chippindale records his eventual rejection of this approach and adoption of the view that 'we will do better to know a little than to believe a lot'. Nevertheless, the question of what to do when confronted with the unknown antiquity continues to puzzle many professionals.[102] To what extent would their refusal to have anything to do with a particular antiquity have an effect on the market? Would their position be taken by others? In an attempt to confront the problem, in recent years a number of bodies involved with antiquities have issued statements reflecting their concern.

Dealers and auction houses

Would destruction of the sources of antiquities and theft be reduced if dealers and auction houses refused to handle objects unless it could be shown that their origin was not so tainted? Part of the answer to this question lies in the extent

[100] Inskeep, R.R. 'Making an Honest Man of Oxford: Good News for Mali' (1992) *Antiquity* 66: 114.

[101] Chippindale, C. 'Commercialization: The Role of Archaeological Laboratories and Collectors' (1993) *Antiquity* 67:699, 702.

[102] 'Instead of cursing the darkness, how do *we* light the candle?': Ravenhill, P.L. 'Beyond Reaction and Denunciation: Appropriate Action to the Crisis of Archaeological Pillage' (1995) *African Arts* (Autumn): 56.

to which dealers and auction houses are currently involved in the illicit trade.

> In twenty years as an art market correspondent, I have never met an antiquities dealer who did not happily handle smuggled goods.[103]

> ... she [Felicity Nicholson, head of Sotheby's antiquities department] finds the occasionally 'shady' side of the antiquities market not uncongenial.[104]

If these quotes give a true representation of the state of the trade, then any effort at all by dealers and auction houses to adopt higher standards should have a significant effect.

One group of dealers which has promulgated the standards by which its members intend to work is the International Association of Dealers in Ancient Art (IADAA). Its Rules, adopted in 1993, contain a Code of Ethics which state in part:

> 12.2. The members of IADAA undertake not to purchase or sell objects until they have established to the best of their ability that such objects were not stolen from excavations, architectural monuments, public institutions or private property.

> 12.3. The members of IADAA refuse to dismember and sell separately parts of one complete object.

> 12.4. The members of IADAA undertake to the best of their ability to keep objects together that were originally meant to be kept together.[105]

The phrase 'to the best of their ability' in paragraph 3 would seem to mean that members would have to use all means available to them in the circumstances to investigate provenance including use of databases. Disregard of the Code of Ethics is ground for suspension of membership of, or expulsion from, the Association.

IADAA is one of the few bodies specifically set up to cover the trade in antiquities; another is the American Association of Dealers in Ancient, Oriental

[103] Norman, G. 'Bad Laws Are Made to be Broken' in Tubb: fn. 12, 143.

[104] Statement from Nicholson's personal review at Sotheby's reproduced in Watson, P. *Sotheby's: Inside Story* (Bloomsbury, London, 1997): 285.

[105] For full text see Appendix II.

and Primitive Art but this does not yet have a code of ethics. There are other associations of dealers:

Art and Antique Dealers League of America
Association des Commerçants d'Art de Suisse
Association of Fine Art Dealers in the Netherlands
Chambre Syndicale de l'Estampe, du Dessin et du Tableau (France)
Comité des Galeries d'Art (France)
National Antique and Art Dealers Association of America Inc.
Professional Art Dealers Association of Canada
Syndicat National des Antiquaries Négociants en Objets d'Art, Tableaux Anciens et Modernes (France)
Syndicat Suisse des Antiquaries et Commerçants d'Art

Most of these also have codes of ethics or practice but none is directly relevant to the destruction of the sources of antiquities and theft from collections.

However, in the United Kingdom, Christie's, Sotheby's, the Society of London Art Dealers, the British Antique Dealers' Association, the Society of Fine Art Auctioneers, the Incorporated Society of Valuers and Auctioneers, the Antiquarian Booksellers' Association, the Royal Institution of Chartered Surveyors, the Fine Art Trade Guild, the British Association of Removers, and the Antiquities Dealers' Association are all party to the *Code of Practice for the Control of International Trading in Works of Art* (hereinafter the British Code).[106] The Code was also adopted (with appropriate adjustments) by the Confédération Internationale des Négociants en Oeuvres d'Art at Florence on 25 September 1987 and Venice on 5 July 1992.

The CINOA Code reads in part:

Members of associations affiliated to CINOA undertake, to the best of their ability, not to import, export or transfer the ownership of such objects [antiques and works of art] where they have reasonable cause to believe:
a) The seller has not established good title to the object under the applicable laws, i.e. whether it has been stolen or otherwise illicitly handled or acquired

[106] For full text see Appendix III.

b) That an imported object has been acquired in or exported from its country of export in violation of that country's laws

c) That an imported object was acquired dishonestly or illegally from an official excavation site or monuments or originated from an illegal, clandestine or otherwise unofficial site.

The use of phrases such as 'to the best of their ability' and 'have reasonable cause to believe' allow considerable latitude to members of affiliated associations. However, they cannot be interpreted as requiring no effort on the part of the member. Firstly, a dealer having the status of a member of an association affiliated with CINOA should be held to a higher standard of knowledge than an ordinary dealer or a member of the public. Secondly, such dealers should investigate the provenance of an antiquity using the means available; for example, databases, museum records, contact with relevant experts.

In 1995 the Intergovernmental Committee for Promoting the Return of Cultural Property to Its Countries of Origin or Its Restitution in Case of Illicit Appropriation[107] considered a Draft Code of Ethics for Dealers in Cultural Property[108] which it was suggested dealers should be encouraged to adopt.

Codes such as that of IADAA, the British Code and the UNESCO Code all ultimately should act as deterrents to those who actually attack sites and monuments for their antiquities or steal from collections. Most of these people have no contact themselves with collectors and would not know how to dispose of an item to a collector. If they cannot find a middleman who will deal with the objects there would be no point in taking them unless they are of precious metal or stones and can be melted or broken down into the basic components. It is thus essential in respect of chance finds that there be an effective system of rewards to encourage reporting and, if the State has ownership, that unwanted antiquities be returned to the finder to sell into the trade if he or she so wishes.[109] With this proviso, the strictures in codes of ethics would work to protect many antiquities provided all middlemen were party to the relevant code of ethics and observed its requirements.

[107] For the background and history of this Committee see O'Keefe and Prott, fn. 44, 855.

[108] For full text see Appendix IV.

[109] See p. 76.

Unfortunately, the provisos are not met. Firstly, not all dealer associations have provisions on objects coming from the destruction of sites and monuments. Even where there are such provisions, members of the relevant associations are usually a small proportion of those engaged in the trade. They are the ones most likely to be concerned about the propriety of handling material gained in such a way even if it is not unlawful under the law applicable to them. Then there is the question of what happens to a member who is found dealing in such material. Under IADAA Rules, for example, the person may be suspended from membership or expelled from the Association. In countries where anyone can buy and sell antiquities this will only be a substantial deterrent if most members of an association control the trade and refuse to deal with that person. There are no figures or examples of associations taking action against their members for breach of the relevant code. In the negotiations leading to adoption of the British Code, provision was made for a Committee to investigate allegations of misconduct and recommend any action thought desirable. In the 10 years that Code has been in existence, the Committee has not acted. One commentator states that 'the Code of Practice appears to have had little effect on the flow of unprovenanced antiquities through the London market'.[110] It will be instructive to see what is made of allegations in print and on television during January/February 1997 of conduct by Sotheby's that appears to breach the Code.[111]

Archaeologists

The Berlin Declaration 1988 by the International Congress for Classical Archaeology[112] stresses the historical significance of an object in the collection of an art museum or museum of cultural history. This, says the Declaration, must not be regarded as less important 'than the material, aesthetic or other values that are applied to it at any particular time'. It then refers to the acquisition of archaeological objects:

The historical significance of objects that appear in the art market or are

[110] Cook, B.F. 'The Transfer of Cultural Property: British Perspectives' in *Eredita Contestata? Nuove prospettive per la tutela del patrimonio archeologico e del territorio* (Accademia nazionale dei lincei, Rome, 1992): 15, 16.

[111] Watson, fn. 104.

[112] For full text see Appendix VI.

newly acquired by museums must also be verifiable: for this reason the record of their discovery (excavation) and their subsequent ownership is essential.

Destruction or falsification of the details of discovery and preservation of archaeological objects is unacceptable from a scientific point of view. Reconstructing the background of an object from stylistic or other criteria alone can never compensate for the loss of its historical context.

In order to prevent the loss of this information and the further destruction of archaeological sites through clandestine excavation, the Declaration enjoins archaeologists not to provide 'authentications or other advice to dealers or private collectors'.

In 1994 the Swiss Academy of Humanities and Social Sciences and the Swiss Liechtenstein Foundation for Archaeological Research Abroad issued a set of Principles for Partnership in Cross-Cultural Human Sciences Research With a Particular View to Archaeology.[113] Preservation and enhancement of cultural diversity was a major aim of this document.

There is no space here to discuss all aspects of the Principles. However, Part A(4) is directly relevant to the present Report:

Archaeologists must never lend their professional competence, directly or indirectly, to illegal and unethical undertakings. They must not evaluate or provide any expertise for such activities. They shall not purchase or accept objects thus obtained, either for themselves or for any private or public person or institution.

Since curators of antiquities collections are also often trained as archaeologists, this provision would reinforce the ethical stance adopted by many museums as discussed above.

On 10 April 1996 the Society for American Archaeology adopted a set of Principles of Archaeological Ethics which includes the following provision:

COMMERCIALIZATION
The Society for American Archaeology has long recognized that the buying and selling of objects out of archaeological context is contributing to the

[113] For full text see Appendix VII.

destruction of the archaeological record on the American continents and around the world. The commercialization of archaeological objects – their use as commodities to be exploited for personal enjoyment or profit – results in the destruction of archaeological sites and of contextual information that is essential to understanding the archaeological record. Archaeologists should therefore carefully weigh the benefits to scholarship of a project against the cost of potentially enhancing the commercial value of archaeological objects. Wherever possible, they should discourage, and should themselves avoid, activities that enhance the commercial value of archaeological objects, especially objects that are not curated in public institutions, or readily available for scientific study, public interpretation, and display.

On its face, this statement would appear to apply to all trade in antiquities. Although the problem is loss of contextual information, it seems to incorporate a blanket condemnation of the trade irrespective of how long the object has been in circulation. Placing a commercial value on an antiquity of whatever age at the very least is to be avoided. Also inherent in the statement is the view that antiquities belong to humanity and should not be appropriated by private persons for their own enjoyment. As such, the statement goes much further than either the German or the Swiss.

Conservators

The training of conservators seeks to imbue respect for the objects entrusted to them for treatment. Consequently, the ethical conservator faces what is at least a moral dilemma when presented with an object that appears to have been recently excavated or in some other way seems to have suspicious origins. Should the object be conserved although that will make it more commercially valuable? Will conservation of that object encourage further theft and destruction of the sources of antiquities? If he or she does not do the work, will someone else do it – perhaps a 'back-street restorer' with little knowledge and ability?

Unfortunately, the Codes of Ethics adopted by various associations of conservators do not provide clear guidance. Some do mention the matter; others are vague. For example, the United Kingdom Institute for Conservation recently issued a Code of Practice which reads in part:

> When a Member knows or has reason to believe the he/she is being asked to work on stolen property, cultural property which has been exported illegally from its country of origin, or imported illegally into the United Kingdom or illegally obtained, it is his/her duty to report this to the police, the Art and Antiques Squad, Customs and Excise and the Cultural Property Unit of the Department of National Heritage.

The circumstances outlined usually involve very complex questions of law on which a conservator may well have difficulty in coming to a decision. As any report to the authorities will almost inevitably lead to controversy, the natural tendency would be to do nothing. The list of authorities to report to is also confusing.

It is obvious from this example and those of other associations,[114] that conservators, as a profession, are unable to agree on what approach they should take. One suggestion has been to emphasize the integrity of an object as well as its physical aspects.

> Perhaps one way would be to make integrity, something that is largely unseen and to which it is hard to assign a value, become a desirable quality in a work of art for both seller and purchaser.[115]

This is a laudable objective but one that really avoids a stand by the conservation profession.[116]

Art historians

Another profession having great influence in the market for antiquities, particularly those of significance, is that of the art historian. Such persons are called on by dealers and collectors to appraise and/or attribute particular antiquities as works of art; to advise on their authenticity and to contribute learned studies extolling their importance. These activities influence the commercial value of

[114] See further O'Keefe, P.J. 'International Rules and Codes of Conduct' in Byrne-Sutton, Q. and Renold, M-A. (eds.) *La restauration des objets d'art* (Schultess Polygraphischer Verlag, Zurich, 1995): 13, 19.

[115] Sease, C. and Thimme, D. 'The Kanakariá Mosaics: the conservators' view' in Tubb: fn. 12, 122, 129.

[116] See further Tubb, K.W. and Sease, C. 'Sacrificing the Wood for the Trees – Should Conservation Have a Role in the Antiquities Trade?' in Roy, A. and Smith, P. (eds.) *Archaeological Conservation and Its Consequences* (International Institute for Conservation of Historic and Artistic Works, London, 1996): 193.

important antiquities and their attractiveness to collectors. It is vital that art historians do not contribute to theft and destruction of the sources of antiquities by these means.

The most recent statement of ethics for art historians on such matters is the *Code of Ethics for Art Historians and Guidelines for the Professional Practice of Art History* (as amended 24 January 1995) produced by the College Art Association of America. In part this reads:

> Art historians are often key players in the international trade in cultural property and have a responsibility to distinguish the licit trade from illicit trade and to suppress the latter. If an art historian is asked for advice by a museum about a prospective purchase that he/she has reason to believe may be coming from out of the country, the reasonable action for an art historian is to satisfy himself or herself that he/she is not contributing to looting. If an art historian is asked by an art dealer or a museum to write a catalogue or render an opinion about a work from antiquity or one from a living cultural tradition, similar inquiry should be made. The realities of the art world sometimes make it necessary for a museum or dealer to withhold disclosing the name of the seller; however, it is such secrecy that has contributed to the problem of the growing and flourishing international traffic in pillaged works of art. In many cases the art historian has placed his/her trust in the reputation of the dealer or museum. Without necessarily calling into question such trust, the art historian should undertake a rudimentary investigation to ensure [*sic*] herself or himself of proper provenance in each situation.

This statement is significant in that it obliges the art historian to at least investigate the origin of an object on which an opinion has been requested and to be satisfied that it is not the product of looting. One would hope that the qualification of the investigation as 'rudimentary' would not weaken the obligation as viewed by members of the Association. Where the art historian has reasonable cause to believe that the object comes from a clandestine excavation or has been unlawfully exported, he or she 'will not assist in a further transaction of that object, including, exhibition, attribution, description or appraisal, except with the agreement of the country of export, nor will an art historian under these circumstances contribute to the publication of the work in question'.

Databases

The advent of electronic databases makes the tracking of antiquities more efficient and effective. It should thus reduce the flow onto the market from illegitimate sources. In particular this will be the case where there is theft from collections and antiquities are removed from monuments where they have been recorded *in situ*. But databases – especially those recording auctions – could also play a role in respect of antiquities from clandestine excavations. Examination of the records might reveal when a particular antiquity came onto the market and where it was sold. This would also be important for the checking of provenance emphasized below.

Commercial databases

Whether databases can fulfil these promises depends on their scope and efficiency. A major commercial database is the Art Loss Register.

> The Art Loss Register is a permanent computerised database of stolen art with images which enables the identification and recovery of stolen art prior to sale when it appears on the art market for auction, when the police recover property believed to be stolen but need evidence to prove their suspicions, and when dealers, museums, galleries and members of the public search the database prior to purchasing works of art, antiques and valuables.[117]

Details of stolen objects are entered on the register by owners or others, such as insurance companies, who have an interest in recovering them. Catalogue data comes electronically from Christie's and Sotheby's and this is searched against the database of listed stolen cultural heritage. Other catalogues – from major and provincial auction houses in Austria, France, Germany, Sweden, United Kingdom and United States of America – are also searched on a regular basis. Operating out of both London and New York, the Art Loss Register also has offices in Paris and Perth (Australia).

Another significant database is The Thesaurus combined with the Active Search System and *Trace*. The Thesaurus database contains information on auction sales both current and since the inception of the business in 1989. The

[117] The International Art and Antique Loss Register Ltd., *1993/1994 Annual Review*: 5.

full printed texts of auction sale catalogues are scanned and fed into the database. Persons who are interested in particular items or categories of items can record their interests which are then matched against the catalogue entries. If a match is made, the person is notified of the upcoming sale. A search can also be made of past entries to see if a particular object, or something resembling it, had been offered for sale through the auction system. Operating in Europe (particularly the United Kingdom) and North America, this database has much to offer in attempting to establish a provenance.

> If a user profile is written for a stolen item there is every chance of it being picked up immediately it is catalogued by an auction room, hopefully before the sale takes place, and remarkable successes have already been achieved using this method. Similarly, user profiles can be prepared in respect of items identified as excavated or exported illegally, so as to alert potential purchasers to the need to exercise particular care in investigating title and provenance of items offered for sale. And in the case of war loot from published collections the full catalogue entries can be entered so as to alert both vendors and purchasers from the other direction as well.[118]

Alternatively, the *Active Search System* could be used. In 1994, Thesaurus bought *Trace* magazine which had a listing of over 40,000 stolen art objects, most of them containing images. From this a service called *Active Search System* (formerly *Tracer*) has been developed. It computer searches continually against auction activity and all available descriptions of recovered items awaiting identification for matches with stolen items on its database. Searching is continued for ten years or earlier recovery. The Active Search System originally ran as an independent entity, 'seeking individual items registered by customers'. It produced an average of forty leads per day to stolen objects. However, its operators found that 'the lead rate is much improved when several items from the same crime are registered together'.[119] As a result, the System recently combined with *Trace* magazine – a publication 'for the protection and retrieval of valued possessions'.

[118] Cannon-Brookes, P. 'The Function of Thesaurus Information in the Museum Environment' from the text of a presentation at the Museums Association Conference, 14 September 1993.

[119] Anon. 'Active Search System to Combine With Magazine' (1996)*Trace* (December): 6.

Yet another system is the Historic Art Theft Database run by Trans-Art International L.C. in Washington (DC). The information held here relates to works of art and manuscripts that have been looted or stolen from both institutional and individual collectors as a result of war (particularly World War II), paramilitary conflict, widespread civil disturbance and political instability. The Database has the dual purpose of enabling persons who have lost their property due to such events to trace it while preserving their legal and equitable ownership rights under the law of the United States of America; secondly, to provide institutional and individual collectors and their agents with a means of checking whether objects that they already own or wish to purchase are not stolen. As Trans-Art International states in its official literature:

> Because War 'trophy' art is appearing on the international market more frequently following the collapse of the Iron Curtain, such items pose special risks to collectors and dealers. Trans-Art set up the Database in a manner that is calculated – under the applicable law – both to diminish the likelihood that works stolen as a result of the War will be acquired, and to protect ownership rights in any such materials that nonetheless may be inadvertently obtained.

The database contains details of more than 40,000 items. Anyone who has lost works of art or manuscripts in the circumstances indicated can have the details entered free of charge. The database cannot be accessed directly by outsiders. Searches are made by staff in the process of undertaking research for an Ownership Due Diligence Certificate which can be requested, subject to a fee, by persons wanting to know whether a particular object has been stolen.

Police databases

There are various police databases which hold information on stolen cultural objects. These are maintained by such bodies as the Office central pour la repression du vol d'oeuvres et objets d'art (France); the Carabinieri tutela del patrimonio artistico (Italy); Scotland Yard (United Kingdom); Federal Bureau of Investigation (United States of America) and the Royal Canadian Mounted Police. Most of the police databases will not release information to private enquirers.

INTERPOL – the International Criminal Police Organization – is an intergovernmental organization whose task it is to promote international police co-

operation. In each member country there is a National Central Bureau which acts as a liaison body between the national police forces and the General Secretariat in France. Information regarding a theft can be sent from a National Bureau to the Secretariat with a request for an international search through the issue of a stolen property notice to other police forces, museums, dealers, auctioneers, pawnbrokers and customs services. Computerized records are kept of the information received and these are available for search by national bureaux. INTERPOL does not handle requests from the public for information.

Networks
To date these databases are still in their infancy as a way of fighting the destruction of the sources of antiquities and theft from collections. A major breakthrough, if it can be brought about, will be a system whereby a search of one database will automatically be a search of all. UNESCO is working with the Getty Information Institute, the International Council of Museums, the Council of Europe and the United States Information Agency to facilitate the exchange of data between systems and, at a meeting held in Prague, November 1997, the possibilities for bringing this about was discussed with managers of existing databases of missing cultural objects. A working group is looking further into the prospects.

Identification
Essential to the efficient operation of databases and the recovery of stolen material is the provision of information of such nature and in such form as to allow identification of the object lost. The Getty Information Institute has been working on an international collaborative project – 'International Documentation Standards for the Protection of Cultural Objects' – that encourages those compiling information on cultural objects to provide 'core' documentation in standardized form. The core data standards agreed by all those consulted – insurers, police, dealers, loss adjusters, collectors, appraisers, database operators, museums – come under the headings: type of object; materials and techniques; measurements; inscriptions and markings; distinguishing features; title; subject; date or period; maker. Photographs are stated to be of vital importance. If there is any additional information, collectors are recommended to also write a short description of the object including this and keep all the information in a safe place.

The next step is to bring the core data standards to the attention of everyone involved so that, if necessary, records can be adjusted to incorporate them. Endorsement by the Intergovernmental Committee for Promoting the Return of Cultural Property to Its Countries of Origin or Its Restitution in Case of Illicit Appropriation would assist in this process.

Changing the market

All the solutions outlined above are intended to operate so as to make it unattractive for persons to loot sites and monuments or steal from collections. The analysis has shown that in certain circumstances they can be very effective. But there are substantial problems, particularly that of identification. Without being able to prove where a particular antiquity came from, it is impossible to recover it in the courts of a foreign State. Standards of behaviour are effective only as long as substantial groups of persons in the particular occupation are prepared to observe them. While there are dealers, collectors, archaeologists and similar professionals who follow codes of behaviour, there are others who do not.

How effective then are these solutions? Considering the current level of destruction and theft, they cannot be operating satisfactorily. Perhaps the time has come to look at changing the market for antiquities. There are ways this could be done.

Render collecting anti-social

Some have compared the current destruction of archaeological sites with that of endangered species of flora and fauna.

> ... if collecting were publicly regarded as something akin to the poaching of endangered animals, private collectors might stop buying unprovenanced objects. Then the demand for antiquities would dry up and the looting of ancient sites would effectively cease.[120]

But how effective has been the campaign to stop 'poaching of endangered animals'? Elephants are still being hunted to extinction in many parts of the world. The very survival of species of rhinoceros is uncertain and the effectiveness of current bans on trade in horn is being questioned. There are proposals

[120] Elia, R. 'The World Cannot Afford Many More Collectors With a Passion for Antiquities', The *Art Newspaper*, No. 41, October 1994: 19, 20.

to legalize the trade in horn in such a way as to drive down the price and so reduce the incentive for poaching.[121]

Others use more restricted analogies; such as the way the wearing of fur has become socially unacceptable in certain countries.[122] This results from campaigns by people concerned at breeding conditions of animals and the killing of them or their cousins in the wild to provide what is considered fashion apparel of high monetary value. Another suggested parallel is that of collecting birds' eggs and wild-flowers – a common pastime in certain countries for many years but now an activity that has almost completely disappeared as a result of moral suasion.[123]

It is impossible to say whether the collecting of antiquities will suffer a similar fate. But there are several aspects to this activity which suggest caution in relying on moral suasion to reduce destruction of the sources of antiquities.

Firstly, animals and birds have an emotional hold on the general populace that is not as widely shared by historic sites and monuments or certainly not in all countries. Many would also argue that the taking of life, even animal life, must be considered as on a higher plane than the destruction of sites, monuments and collections of antiquities. Such an argument does ignore the traumatic effect on human life, very evident in wartime, of the destruction of cultural heritage and its effect on the quality of human life.

Secondly, antiquities have been pursued by collectors for many centuries and the interest appears to be broadening. Wearing fur, on the other hand, really became a target when it became a fashion item and symbol of conspicuous consumption.

Thirdly, there should be caution in accepting the notion that antipathy to the collecting of animals and the wearing of fur is world-wide and unanimous. Fur is still widely worn in many countries[124] and hunting is regarded as part of the cultural heritage of many peoples.

[121] *The Economist*, 20 April 1996, 86–87.

[122] Chippindale, fn. 101, 703.

[123] Addyman, P.V. 'Treasure Trove, Treasure Hunting and the Quest for a Portable Antiquities Act' in Tubb: fn. 12, 163, 169.

[124] The *Financial Times* reports that demand for fur has risen substantially in Russia and China but also in North America: 13 February 1997: 11.

Finally, there does not appear to be a consensus, even among archaeologists, that this is the way to approach the problem. For example, the newly appointed Lincoln Professor of Classical Archaeology and Art at Oxford University, when asked the question

Another idea is to try and shame collectors into ceasing to buy. Do you think that would work?

replied:

Maybe. But I don't think this should be a question of shame or moral pressure and it shouldn't be up to people like you and me to bring moral pressure on buyers; it should simply be like everything else that society feels strongly about – it should be a matter of law.[125]

Render certain collecting anti-social

Instead of attempting to render all collecting anti-social – such as has been done for birds' eggs in certain countries as mentioned above – it would be more productive to bring about change in public attitudes that would render the collecting of certain antiquities unacceptable; antiquities which are undocumented, unprovenanced, looted, smuggled or stolen. A campaign to this end might be more effective if the flow of antiquities from legitimate sources were maintained or increased.[126]

To bring about the suggested result would required a sustained campaign in all media highlighting the destruction caused by taking antiquities from illegitimate sources. It would need exposure of all elements of the trade that contribute to the destruction. Such an attitude as that expressed by the Sotheby's official, Nicholson,[127] would need to be ruthlessly exposed to the glare of negative publicity. The secrecy surrounding the trade would need to be cut away.

There will of course be many cases where documentation does not exist and in fact nothing is known of the origin of the object. For example, in 1988 the London auctioneers, Bonham's, included in their catalogue for a coming sale a

[125] Interview by Boucher, I. The *Art Newspaper*, No. 50, July–August 1995: 20.

[126] See p. 66.

[127] See p. 48.

'rare and important early nineteenth century Maori Mokomakai preserved human head'. Newspapers revealed that the head had been found in the attic of a house in Suffolk in England where it had apparently been for more than 100 years. How it got there was not known although an ancestor of the vendor's husband had worked in New Zealand as a whaler and later settled there. The supposition was that the head had been passed on by this ancestor but whether this was so and how it had come about could never be proven.[128]

In order to take account of situations such as this, it would be wise to adopt a date from which the campaign would take its starting point. Some might suggest 1970 as a reasonable point of time as it was then that the UNESCO Convention was finalized and the problem began to be widely reported to the post-war world.[129] On the other hand, many States did not become party to that Convention till well after 1970 and some important ones have still not accepted it. There was no legal obligation involved and little recognition of an ethical situation till a much later date. In these circumstances, and in light of the fact that for antiquities already in circulation the damage to context has already been done, a current date would seem preferable – one that would allow everyone to start with a clean slate. This would not affect legal rules which could require a search much further back in time.[130] It would mean that dealers and auctioneers would undertake, at a minimum, not to deal in antiquities lacking a provenance from that date.

Reduce taxation incentives

In addition to publicity and campaigns of education, States could reduce the financial attractiveness of collecting antiquities which are unprovenanced as described above. At the moment, a number of States allow persons liable to taxation to reduce their liability by transferring items of the cultural heritage to public institutions or by allowing the public access to them. There are many variations as to how this may be done. For example, in England, an owner may

[128] O'Keefe, P.J. 'Maoris Claim Head' (1992) *International Journal of Cultural Property* 1: 393.

[129] It should be noted that much work was done on preparing an international instrument to tackle the problem in the 1930s: see O'Keefe and Prott, fn. 44, 708ff.

[130] For example, the *UNIDROIT Convention on Stolen or Illegally Exported Cultural Objects* provides that the possessor of a stolen cultural object required to restitute it is entitled to compensation provided due diligence can be proven.

be granted conditional exemption from capital transfer tax or inheritance tax provided reasonable steps are taken to provide reasonable public access to the item.[131]

Under none of these schemes does there appear to be any attempt to ascertain how the person claiming the tax relief acquired the item and what its previous history was. It would be relatively easy for States operating such systems to require details to be given of the whereabouts of any antiquity over a set period of years (e.g. since the date mentioned above) as part of the general process of claiming a deduction.

This would not prevent persons collecting antiquities even though they were not able to ascertain the history of an object for the relevant period. But it would prevent the use of public funds to subsidize activity at odds with the long term interest of humanity. To a certain extent it would reduce the market for those who are prepared to destroy sites and monuments or steal and thus make their activity less remunerative. Where it would not be effective would be in respect of antiquities bought for purely decorative purposes. These are not of museum quality and are not purchased with any taxation benefit in mind. Here education and publicity campaigns would be essential.[132]

Trade incentives

There are various incentives that could be offered those who trade in antiquities to adapt their practices so as to reduce theft and destruction of the sources of antiquities. It would take imagination on the part of governments and the willingness to forgo, for example, certain taxation income.

Dwyer suggests that an economic stimulant is essential to the development of 'any open and licit market in cultural property and be generated by that market'.[133] Incentives of this nature are probably likely to be more effective than prohibitions and penalties. He suggests the levy of a tax on sales of antiquities equal to what the local government authorities receive. This is certainly one way of proceeding but may not act as a stimulant to disclosure.

[131] For a detailed discussion of various schemes see O'Keefe and Prott, fn. 44, 165–82.

[132] See p. 95.

[133] Dwyer, E. 'Critical Comments on the Draft Principles to Govern a Licit International Traffic in Cultural Property' in Briat, M. and Freedberg, J.A. *Legal Aspects of International Trade in Art* (ICC Publishing, Paris; Kluwer, The Hague; 1996): 105, 108.

Any taxation scheme should encourage the provision of provenance and the absence of secrecy which, as Bator points out,[134] is endemic in the trade but antithetical to many of the interests involved. It should be possible, considering the almost universal use of computerized taxation records in developed States, to introduce differential rates of tax. For example, if the standard rate of tax on the sale of an antiquity is five per cent, then reduce it to three per cent if the name and address of the seller and buyer are made public or available to the public. Alternatively, in cases where the information is not available, an extra percentage tax could be added to the normal rate. These are only illustrations of what could be done. The mechanics of these and other possible schemes need to be worked out in more detail than is possible here. It is recommended that UNESCO undertake further study of possible incentives and how they could be implemented.

Financial assistance

As mentioned earlier,[135] one of the problems for countries with extensive remains of former civilizations is to provide effective security and conservation of sites; pay rewards to finders and compensation for loss of land or construction time during archaeological excavation. If the second suggestion made above were adopted, the extra tax collected from transactions with secret details could be devoted to at least partially solving this problem. For example, if the State A were to charge the extra tax it could donate the income to State B for such purpose. Even better would be for the tax authorities in State A to hand the money to that country's administrative service concerned with sites and monuments which would then deal directly with its counterpart in State B.

Increase volume flow

If there were a flow of a broad range of antiquities onto the market with certification that they had come from an authorized source, would the destruction of sites and monuments and thefts from collections be reduced?

The answer to this question involves a number of assumptions. Firstly, that such a flow could be achieved. Secondly, that collectors would be more attracted to this material than to objects without certification or a legitimate provenance.

[134] Bator, P.M. 'An Essay on the International Trade in Art' (1982) *Stanford Law Review* 34: 275, 360.

[135] See p. 19.

Thirdly, that the flow would reduce the market for antiquities gained in the destruction of sites or monuments or from theft so that it would no longer be financially rewarding for people to engage in such activities.

As for the third assumption, existing and historical examples of free trading urge caution in accepting its validity.

In the case of Peru, there is no evidence that a licit market in antiquities would limit the illicit or black market that has financed the destruction of so many archaeological sites. Peru has had numerous periods of an open, legal, internal and, to a lesser degree, external antiquities market during this century. Until the 1960's, there was a legal internal market, antiquities dealers flourished and even Sears-Roebuck had a 'pre-Colombian' art department in its main Lima store. The Peruvian government allowed Paracas mummy bundles to be given by the National Museum of Anthropology and Archaeology to Nelson Rockefeller in the United States and initiated gifts of antiquities to government officials in Spain and Chile. At about the same time, the National Museum of Anthropology and Archaeology was also selling Paracas textiles to various international museums and dealers to supplement its own operating budget. Various other deals and splits were sanctioned by the Peruvian Government. These gave foreign interests permission to excavate and allowed the removal of archaeological collections to museums in the United States and Europe in return for financial support and the training of local specialists and other considerations. One can think of the great documented collections of Peruvian antiquities in Sweden, Germany and in the United States (at Berkeley, University of Pennsylvania and Harvard) that were legally exported. But during this same period, grave robbers worked to feed both the legal and parallel illegal market. Public and private collections grew nationally and internationally while archaeological sites were literally turned into lunar landscapes.[136]

A current example could be that of the United States of America where there is a considerable legal market for Native American antiquities obtained from private land. At the same time, there is a serious looting problem both on public and private land.[137]

A problem with the third assumption is that it rests on a supposition that

[136] Dwyer, fn. 133, 106.

[137] King, T.F. 'Some Dimensions of the Pothunting Problem' in Smith, G.S. and Ehrenhard, J.E. (eds.) *Protecting the*

market demand for antiquities is inelastic. In other words, the assumption will be false if the market merely expands to absorb the increased flow of antiquities rather than choking off replenishments from illegitimate sources. It is impossible to predict whether this will occur. There are some indications that it may take place to a certain degree but not such as to absorb the full increased flow. One factor is the entry into the market of buyers for less expensive pieces – decorative antiquities – encouraged by marketing techniques adopted by certain dealers and auction houses.

However, these considerations should not prevent further study of the proposal and how it might be implemented. There is no suggestion that all destruction of sites and monuments will be stopped by increasing the flow of antiquities. What is necessary is a short term means of satisfying demand so as to allow for other measures to operate to lessen or redirect demand in the long term.

There is evidence that some, probably most, collectors would be more attracted to objects with certification or a legitimate provenance than those without. The market recognizes this by establishing a price differential between antiquities with provenance and those of similar quality without.[138] As discussed above, there is evidence that the absence of an export certificate affects the market value in appropriate cases.[139]

Can an increased flow of desirable antiquities be achieved? While some collectors will be satisfied with a pottery sherd,[140] others will seek the truly unique object which gives great aesthetic and sensual pleasure. The flow of antiquities would have to satisfy the entire spectrum.

Available evidence suggests that dealers would be interested in handling material of a broad range of quality. This is borne out by discussion with various persons in the trade and observation of the contents actually in dealers' showrooms. Not all agree with such assessment. Coggins takes the following view of dealers and their desired wares:

Past (CRC Press, Boca Raton, Florida, 1991): 83.

[138] Cannon-Brookes, P. 'Antiquities in the Market-place: Placing a Price on Documentation' (1994) *Antiquity* 68: 349.

[139] See p. 28.

[140] '... as the number of fine antiquities continues to diminish, buyers will almost certainly consider fragments': New York dealer Robert Haber quoted in Vincent, S. 'Going Greek: You Won't Find Classical Bargains by Looking in the Attic' (1995) *Art & Auction* (December): 80.

They want the very singular objects most countries would choose to keep, as one dealer wrote:

> I for one, do not want to live in a xenophobic gray world of endlessly rotating travelling shows, coffee table books of ever-increasing gaudiness, and – God forbid – plaster casts from overseas. I want continually to look at new and beautiful objects that delight the senses and excite the mind.

> These words express the feelings of most antiquities dealers; from them one must conclude that talk of 'duplicates' which will supply, even satiate, the market is a smoke screen for inaction.[141]

Certainly there are such dealers but there are also others who prefer to handle more common objects.[142] Eisenberg, director of Royal-Athena Galleries in Beverly Hills and New York, is quoted as stating that:

> Material valued at up to a few thousand dollars is certainly 90 per cent of the business.[143]

How could such an increased flow be brought about? There are three possible sources: disposals from collections; enhancement of procedures for dealing with chance finds and distribution of finds from new excavations.[144] This does not mean excavations purely to augment the trade. However, there are situations where governments, acting on the advice of the responsible authority, may authorize the disposal of antiquities from official excavations.

Collections

From time to time it is suggested that certain museums and collection points hold vast quantities of antiquities that could be usefully disposed of. Merryman makes this argument in his study of the nature of the licit trade:

[141] Coggins, C.C. 'A Licit International Traffic in Ancient Art: Let There Be Light' (1995) *International Journal of Cultural Property* 4: 61, 67.

[142] Windsor, J. 'At Sotheby's They Can Fetch £2m. Chris Martin Will Sell You a Similar Ancient Artefact for Under £100' The *Independent* 1 July 1995.

[143] The *ARTnewsletter*, No. 22, Vol. XIX, 28 June 1994: 3.

[144] These methods have been advocated by others over the years but they have never before been formally considered by an intergovernmental body as a way of reducing the flow of antiquities from illegitimate sources.

> Source nations that already hold significant supplies of redundant objects in storage, as many are said to do, could begin to release them to a licit market...[145]

Dealers stress this point and the revenue that could be obtained.

> The sale of duplicate objects of minor value by the member states from their museum depots could bring a significant revenue for their use... untold hundreds of millions of dollars in minor ancient objects lie forgotten in storage in museums in Europe and America.[146]

> ... the magazines and museums around the Mediterranean are bursting at the seams with antiquities which are poorly conserved and never see the light of day. Is it really in the interests of world cultural heritage that this should be so? [147]

Others disagree:

> Many, many archaeologically-rich countries do not have storerooms full of 'duplicates'. Whereas, if those countries in which their ancestors did, in fact, produce duplicates, like fired clay oil lamps and water vessels, should decide to sell some – the art dealers would not want them.[148]

> ... in the case of archaeological objects from the pre-Columbian culture of Teotihuacán, is it conceivable that any of the large greenstone masks, of which there are at least one hundred in Mexican museums, as well as many more in private collections in Mexico, would be declared surplus by the State? It would seem very unlikely, as legitimate arguments for retention would be made based on the uniqueness, educational and cultural significance, beauty and commercial value of each mask.[149]

[145] Merryman, J.H. 'A Licit International Trade in Cultural Objects' (1995) *International Journal of Cultural Property* 4: 13, 37.

[146] Eisenberg, J.M. 'Ethics and the Antiquity Trade' in Tubb: fn. 12, 215, 220.

[147] Ede, J. 'The Antiquities Trade: Towards a More Balanced View' in Briat, M. and Freedberg, J.A. *Legal Aspects of International Trade in Art* (ICC Publishing, Paris; Kluwer, The Hague; 1996) 69, 71.

[148] Coggins, C.C. 'A Licit International Traffic in Ancient Art: Let There Be Light' (1995) *International Journal of Cultural Property* 4: 61, 67.

[149] Seligman, T.K. 'What Value in Surplus Cultural Property?' in Briat, M. and Freedberg, J.A. *Legal Aspects of International Trade in Art* (ICC Publishing, Paris; Kluwer, The Hague; 1996): 131, 132.

Nevertheless, the allegation has been made and must be investigated.

Those who support the proposition say that this material has sat in basements for many years; it is never studied and never displayed. The excavation records have disappeared or never existed. As such the material has lost its historical value. Much of it consists of duplicates or multiple copies so that the retention of one or a couple would be sufficient for museum and informational purposes. The remainder should be deaccessioned, if it ever was properly accessioned, and sold on the international market. Past practice of the Cairo Museum is used as an illustration of what could be done:

> ... the Cairo Museum maintained, at least until 1950, a 'Salle de Vente' where surplus material, often of surprising quality, could be bought by institutions as well as private individuals.[150]

In the course of researching this Report it became evident that no-one really knows the extent of collections of the kind suggested. There is much anecdotal evidence that they exist but nothing of substance. Moreover, it may be difficult for administrators of such collections to publicly acknowledge the fact and to acquiesce to disposal. In practice, some museums and collection points may not even know what they possess as inventories are out of date, incomplete and sometimes non-existent. A prime objective should be to establish whether there are in fact 'redundant' antiquities in storage around the world. These could be in the charge of museums or various government agencies. Consequently, any assessment of the situation would have to be done by a body capable of dealing with all authorities. A small commission of persons eminent in the field (representing collectors both public and private, dealers and archaeologists) appointed by the Intergovernmental Committee for Promoting the Return of Cultural Property to Its Countries of Origin or Its Restitution in Case of Illicit Appropriation and supported by UNESCO would seem to be most appropriate. Relevant international organizations such as ICOM and the International Council for Monuments and Sites together with various national professional associations could be asked to assist.

Those who make the assumptions and suggestions above are usually concentrating their attention on holdings of antiquities in Mediterranean countries

[150] Bothmer, B.V. 'Response to a letter from the Egyptian Organisation of Antiquities' (1983) *Journal of Field Archaeology* 10: 103, 105.

– particularly Italy, Greece and Egypt – and some in South America. However, the same argument holds true for all the world's great collections. Where these hold multiple examples of particular antiquities they should be affected by the same policy. If there is to be a move to encourage such disposal, it cannot be discriminatory. A general policy would have to be developed to take account of all holdings and all institutions.[151] Such an innovation would require certain changes, particularly in museum practice, and implementation of various safeguards to ensure that no knowledge was lost in the disposal of the antiquities.

Collection and retention of objects has developed as a major principle of museum practice over a number of years. For example, the *Code of Professional Practice* of the International Council of Museums (ICOM) states in para. 4.1:

> By definition one of the key functions of almost every kind of museum is to acquire objects and keep them for posterity. Consequently there must always be a strong presumption against the disposal of specimens to which a museum has assumed formal title.

The Code goes on to point out that there may be legal restrictions on the ability of a museum to dispose of objects from its collections. In countries such as France, state museums are forbidden by law from disposing of any part of their collections. Another case may be a museum that has given an undertaking to a donor to keep a collection intact in perpetuity.

Where restrictions have been complied with, or do not exist, the Code recommends that material 'should be offered first, by exchange, gift or private treaty sale, to other museums before sale by public auction or other means is considered'.[152] This could be made to work within the general objective of increasing the volume of antiquities on the market but is obviously not directly conducive to it.

More significant is the attitude of the ICOM Code towards disposals which is cautious at best but verging on adverse. The same can be found in other codes of ethics. The *Statement of Professional Practices in Art Museums* (1992) issued by the Association of Art Museum Directors in the United States of America includes in paragraph 24:

[151] We cannot agree with those such as Sir John Boardman who would appear to restrict this policy to museums in the so-called 'source' countries: Broadman, J. 'Don't Just Berate the Thieves: Look at the Museums and Excavators Too' The *Art Newspaper*, No. 54, December 1995: 20.

[152] Para. 4.3.

Disposal of works of art from a museum's collection by sale, exchange, or otherwise, requires particularly rigorous examination and should be pursued with great caution. Although there are circumstances in which disposal of works of art can contribute to the strengthening of a collection, such disposal must be related to the museum's written policy rather than to exigencies of the moment.

Also of interest is the *Code of Ethics for Museums* issued by the American Association of Museums in 1994. In part this reads:

... disposal of collections through sale, trade, or research activities is solely for the advancement of the museum's mission.

These and other codes indicate that this issue needs to be discussed further in museum organizations if collections are to become a source for increasing the flow of antiquities onto the market. Museums will have to find a common policy in this regard. Those in the Mediterranean countries and South America cannot be required to adopt a different policy to others.

There are no codes of ethics regarding holdings of antiquities in State collection points. What is done with these depends on government policy. Relevant representatives would need to be involved in the formulation of any policy.

Also to be considered is the fact that a collection from an excavation constitutes an archive. If kept together it can be returned to again and again as required by research needs. There have been examples of objects yielding additional information years after it was thought everything had been extracted from them. Moreover, collections of material from archaeological excavations are sometimes reinvestigated in the light of techniques not available at the time they were brought out of the ground.

But not all material is necessarily of equal value. A collection may result from a meticulously conducted excavation and form an excellent archive although even here there may be items from a disturbed context. Another may be the product of a rescue excavation conducted with the thoroughness allowed by the time permitted and the skill of the excavators. Yet another may be comprised of objects with no excavation record or one where the record is missing. For example, in the United States of America, surveys over the past decade of collections under the control of Federal Government agencies have revealed a

lack of inventories; the loss or destruction of records; the splitting of records and objects.[153] If that is the situation in a country with such facilities for conservation and preservation, what is the position likely to be elsewhere?

The question must also be asked how long States can continue to store all material from excavations. The cost of simple storage, let alone storage in controlled conditions suitable for conservation, is rapidly becoming prohibitive even in the most wealthy countries.[154] In the course of research for this Report and other activities, the writer has seen storage areas full of collapsing boxes containing the results of archaeological excavations. Some of the contents would attract collectors. When there are insufficient funds to adequately store antiquities in conditions where later research could be meaningful, is there any point in keeping them? International guidelines would need to take account of all aspects of this issue.

It is recommended that States request the Director-General of UNESCO to put before the Intergovernmental Committee for Promoting the Return of Cultural Property to Its Countries of Origin or Its Restitution in Case of Illicit Appropriation a list of persons representing collectors (both public and private), dealers and archaeologists. The Intergovernmental Committee would then select from that list a small number of persons to form a commission to establish, as a matter of urgency, whether there are collections with extensive holdings of antiquities that could be released onto the market and whether the development of a policy to this effect is desirable.

The Commission could also investigate whether the problems of splitting a collection could be overcome by keeping a register of where objects sold are currently housed – or at least those of a certain importance. Would this be feasible? Could the use of electronic databases overcome the logistical difficulties in keeping track of where the object is located following change of ownership? Who would be responsible for such a database? It must be acknowledged that the information contained in it would be of commercial interest and sometimes significant to government officials, particularly for fiscal reasons.

[153] Childs, S.T. 'The Curation Crisis' (1995) *Federal Archaeology* 7: 11.

[154] For example, it is reported that the Museum of London 'has now decided to place the 100,000-or-so boxes of pottery and bone, tile, glass and other finds contained in its warehouse into 'dead storage' – the finds will no longer be actively curated, access to the material will be restricted or stopped altogether, and no new finds will be accepted': *British Archaeology*, March 1966: 4; see also Lord, B.; Lord, G.D. and Nicks, J. *The Cost of Collecting: Collection Management in UK Museums* (Her Majesty's Stationery Office, London, 1989).

Any disposal for the purpose of reducing demand will require a decision within the museum or government administration. The codes quoted above all state that this must be made at the highest level of decision making within the institution. But this level will have to rely on advice given from below; from curatorial staff and others of similar rank. The crucial question is whether all museums and collection points will have staff with sufficient time and experience to make a proper assessment of the implications of particular disposals.

Those who do not could seek assistance from outside the institution. Major international dealers and auction houses might be prepared to assist in such assessment subject to suitable guarantees against mistakes and posting of security to cover dishonest behaviour. Provided conflict of interest considerations could be overcome, their services might be provided as part of a package deal whereby they handle the sale of the antiquities concerned on a commission basis. This would be of benefit to the institution in that any assessment of disposals would require a study of the whole collection before an informed judgement could be reached. It would bring to bear international expertise and give the institution a better knowledge of what it possesses. Alternatively, wealthy institutions with expertise in this area such as certain museums might be prepared to provide assistance.

Disposal of antiquities from collections could be restricted to dealers and auction houses who have bound themselves to observe the Code of Ethics already considered by the Intergovernmental Committee for Promoting the Return of Cultural Property to Its Countries of Origin or Its Restitution in Case of Illicit Appropriation. In this way governments would encourage dealers to handle only legitimate material. Other dealers would find their markets restricted as purchasers went to those where they could obtain properly provenanced antiquities.

Finally, the obvious point must be made: existing collections are finite and disposal of material from them would not last indefinitely. This could only ever be a partial and short-term answer to the problem.

Chance finds

Chance finds of antiquities are constantly occurring in countries long occupied by humanity: coins, ceramics, ornaments and all other types of antiquities. Excavation for construction projects, deep ploughing, erosion of land all bring

about their uncovering. As discussed earlier, the law in many States requires any such discovery to be reported to the authorities. This is incorporated in the 1956 UNESCO *Recommendation on international principles applicable to archaeological excavations* which says that States should:

> Oblige any person finding archaeological remains to declare them at the earliest possible date to the competent authority.

States Party to the *European Convention on the Protection of the Archaeological Heritage (Revised)* 1992 are obliged to require (Article 2(iii)):

> the mandatory reporting to the competent authorities by a finder of the chance discovery of elements of the archaeological heritage and making them available for examination.

In some States the authorities have the right to keep the antiquity. There is nothing on this in the 1956 Recommendation apart from the provision on the archaeological subsoil[155] and the European Convention says only that the finder must be obliged to make them available for examination. By way of inducement, the State often pays a reward to the finder. If it decides to keep the antiquity, the finder may be compensated.[156]

Payment of rewards and compensation for doing what the law requires may be seen by some as unethical, if not wrong; particularly where the State owns undiscovered antiquities. Nevertheless, while there are impoverished local populations; while education in the values of cultural heritage is still rudimentary; while the ethic of 'finders keepers' is still embedded in the public consciousness,[157] it is necessary to encourage people to report any chance finds and to compensate finders. The reality of the situation was expressed by Walsh J. in the case *Webb* v. *Ireland*:

> I fully recognize that as a matter of prudence and indeed as a way of safeguarding similar such objects as may in the future be found that it could well be regarded as expedient on the part of the State, not merely to reward

[155] See. p. 35.

[156] These matters are discussed in more detail in O'Keefe, P.J. and Prott, L.V. *Law and the Cultural Heritage: Volume I: Discovery and Excavation* (Butterworths, London, 1984) 206ff.

[157] Norman, fn. 103, 143.

such persons but generously to reward them for the sake of ensuring, or assisting in ensuring, that the objects will be disclosed to the State and will be dealt with by the State, for the benefit of the common good in accordance with the law for the time being in force.[158]

Where antiquities are found purely by chance (and not by deliberate search), lesser pieces and duplicates should be returned to the finder. The finder should be allowed to sell these if he or she so wishes and thus they would become available to the trade.

It should be recognized that, although the State has an interest in retaining important antiquities discovered in this way for itself, another major interest is in learning where the antiquity was discovered. It may indicate the existence of a site requiring further scientific study. Moreover, the record of discovery may be important for statistical and other investigations relating to distribution patterns. All these argue for the operation of an efficient and effective reward system.

The level of reward paid depends on many factors but should lead finders to report their discoveries while not encouraging unauthorized search for, and excavation of, antiquities. While Walsh J. above states that the reward should be generous, this does not require a linkage to international values for antiquities. It should be generous in terms of what the finder could expect to receive locally taking into account prices paid on the black market.

Equally as important is the existence of a quick and efficient system for ascertaining and paying the reward. A poor farmer or labourer on a construction site will find cash from a dealer more attractive than a problematic larger sum in the distant future. Moreover, people must not be disadvantaged for reporting a find. In particular, they must not be treated by police and other officials as though guilty of concealment. If it is thought necessary to set the site aside for thorough examination, compensation is necessary for any loss of production or other usage.

The issue of rewards raises the problem of metal detecting and how finds made in this way should be treated. These machines are common in many countries and are becoming of increasing sophistication while their purchase price is dropping. Reports indicate that even where local people do not use or

[158] Fn. 72, 605.

know of metal detectors, tourists may well arrive with them. Many people use them in the deliberate search for antiquities. How should the finder of an antiquity by such means be treated so that destruction of sites is reduced?

In those countries which prohibit the unauthorized search for antiquities, the use of a metal detector for this purpose will usually be a crime.[159] What happens to any antiquity discovered will depend on the local law which may provide for forfeiture. But proof of such a crime could well be difficult to obtain e.g. does the prosecution have to prove that the person was using the metal detector for the specific purpose of searching for antiquities and what is the nature of the proof? Some countries avoid this problem by prohibiting the possession of metal detectors unless authorized.

Irish law refers to what it calls 'detection devices' i.e. 'a device designed or adapted for detecting or locating any metal or mineral on or in the ground, on, in or under the sea bed or on or in land covered by water, but does not include a camera'. The use or possession of such a device is prohibited in specified places e.g. the site of a registered monument, a registered archaeological area or a restricted area. Use of a detection device at any other place, 'for the purpose of searching for archaeological objects', is also prohibited. The Irish legislation recognizes that people can easily be misled by media announcements extolling the thrill of treasure hunting. Consequently, it is prohibited to 'promote, whether by advertising or otherwise, the sale or use of detection devices for the purpose of searching for archaeological objects'.

Sweden has also recently faced the problem of metal detectors. There, the use of any apparatus which could be 'used for electronically tracing objects below the ground surface (metal detectors)' is prohibited except for the Central Board of National Antiquities and specified circumstances such as military activity in searching for things other than archaeological finds. Breach of the prohibition may lead to forfeiture of the antiquity or its value together with the metal detector and other equipment used in committing the crime.

All the above shows that there is no consensus of opinion on how finds made by metal detector users should be treated. In some countries they will be the property of the landowner or the finder; in others they will be seized. In the latter case, those of no great significance to the State could be sold into the trade.

[159] See generally in relation to prohibitions on searching, O'Keefe and Prott, fn. 156, 203.

Failure to report a find should attract penalties, usually a monetary fine or a term of imprisonment. Both of these need careful consideration in the light of local conditions. They should bear some relationship to the local value of the objects likely to be found and the circumstances of the offender. For example, the Mexican *Federal Act on Monuments and Archaeological, Artistic and Historic Zones* 1972, provides:

> The educational background, customs and conduct of the accused, his economic or financial situation, motives and the circumstances that impelled him to commit the crime shall be taken into account in adjusting the penalties referred to in this Act.

The fact that there is a requirement to report; the promise of a reward for doing so as well as the applicability of penalties for failure in this should all be widely publicized.

New excavations

In certain circumstances new excavations could be a source of antiquities for the trade. For example, excavation on private land in many states of the United States is lawful as is trading in any finds made. In England, excavation is permitted on private land, either by the landowner or those he/she has authorized, provided the area is not a scheduled ancient monument. The finds go to the landowner who is normally the party in possession provided they are not treasure trove or subject to a prior agreement between the landowner and the finder.

But deliberate excavation for the purpose of feeding the trade in antiquities is at odds with longstanding policies of UNESCO and the International Council for Monuments and Sites (ICOMOS). It is contrary to the spirit, if not the precise wording, of the *European Convention on the Protection of the Archaeological Heritage (Revised)* 1992.

Excavation reduces the availability of sites for future generations. Much has already been lost and the generally accepted archaeological approach endorsed by States and international organizations is to regard excavation as the ultimate step in investigating a scientific problem. Under Article 3(i)(b) of the *European Convention on the Protection of the Archaeological Heritage (Revised)* 1992, States party are:

to ensure that archaeological excavations and prospecting are undertaken in a scientific manner and provided that:
 – non-destructive methods of investigation are
 applied wherever possible.

Article 4 requires States to implement measures for the physical protection of the archaeological heritage including its conservation and maintenance 'preferably *in situ*'.

This approach is expanded in Article 5 of the ICOMOS *Charter for the Protection and Management of the Archaeological Heritage*:

> It must be an over-riding principle that the gathering of information about the archaeological heritage should not destroy any more archaeological evidence than is necessary for the protectional or scientific objectives of the investigation.
>
> . . .
>
> In exceptional cases, unthreatened sites may be excavated to elucidate research problems or to interpret them more effectively for the purpose of presenting them to the public. In such cases excavation must be preceded by thorough scientific evaluation of the significance of the site. Excavation should be partial, leaving a portion undisturbed for future research.

The Charter recognizes that excavation should be carried out on sites and monuments threatened by 'development, land-use change, looting, or natural deterioration'. In similar vein is the ICOMOS *Charter for the Protection and Management of the Underwater Cultural Heritage* which includes among its fundamental principles the following:

> The preservation of underwater cultural heritage '*in situ*' should be considered as a first option.
>
> Non-destructive techniques, non-intrusive survey and sampling should be encouraged in preference to excavation.
>
> Investigation must not adversely impact the underwater cultural heritage more than is necessary for the mitigatory or scientific objectives of the project.[160]

[160] Reproduced in (1997) *ICOMOS News* 7: 25, 26.

In the interests of preserving the record of humanity's past, the underlying philosophy of this policy should be endorsed. Excavation should have a serious, scientific purpose of benefit to the community. There should be no excavation solely for the purpose of feeding the international trade in antiquities. At the same time, there needs to be serious debate, not only in archaeological circles, but in the wider community of any policy resulting in almost total lack of excavation.

> An archaeology without excavation is one that cannot achieve its potential social contributions. ... a policy that either directly or de facto shuts off even frugal, well-justified research on important archaeological resources ultimately does not serve archaeology or the public good.[161]

There can be excavations under the circumstances set out in the ICOMOS Charter and objects attractive to collectors will be found in them. The excavations will be controlled by the national archaeological administration. They will be conducted by that body or by those authorized by it – in the main, local or foreign institutions devoted to public purposes. It was for many years a common practice for the latter to be authorized to excavate named sites under specific conditions.[162] Although this is still done, in practice it is being limited: sometimes for the policy reasons espoused by ICOMOS; sometimes for reasons of national pride and sometimes as a result of alleged abuse by certain excavators: abuses such as smuggling of objects out of the country; non-return of objects taken out for scientific research; failure to publish the results of the excavation.

Where foreign institutions are allowed to excavate, there may be provision for division of the finds.[163] Some countries allow the foreign institution complete discretion as to what it does with its allocation. It could dispose of the antiquities onto the market if it so wished. But the majority of countries impose a condition that the institution must make the antiquities available to researchers and the public. This approach is to be found in paragraph 23(c) of the 1956 UNESCO *Recommendation on international principles applicable to archaeological excavations*:

[161] Lipe, W.D. 'In Defense of Digging: Archaeological Preservation as a Means, Not an End' (1996) *Cultural Resource Management* 19 (No. 7): 23, 24.

[162] O'Keefe and Prott, fn. 156, 232ff.

[163] Fn. 156, 284.

81

With the main object of promoting archaeological studies through the distribution of original material, the conceding authority, after scientific publication, might consider allocating to the approved excavator a number of finds from his excavation, consisting of duplicates or, in a more general sense, of objects or groups of objects which can be released in view of their similarity to other objects from the same excavation. The return to the excavator of objects resulting from excavations should always be subject to the condition that they be allocated within a specified period of time to scientific centres open to the public, with the proviso that if these conditions are not put into effect, or cease to be carried out, the released objects will be returned to the conceding authority.

This policy effectively excludes persons such as collectors and dealers from involvement in lawful excavations for any but purely altruistic reasons.[164] Any finds cannot be traded and thus the economic incentive does not exist for dealers. If the policy were to be changed, and collectors invited to assist in supporting legal excavations, they would have to open their collections to researchers and the public. Some collectors do this already for collections of antiquities acquired by purchase.

Excavation supported by dealers and collectors would be unlikely and complicated. It would be unlikely because excavation must be done according to proper archaeological standards and this is time consuming and costly. A site may take many years to dig. Much that is found will have no commercial value but nevertheless will have to be conserved and stored. Yet more years will be required for analysis. For example, it is said that a month's work on an underwater site will require two years on conservation, recording and publication.[165] During this time even objects of commercial value cannot be dispersed as the researchers will require access to them.

Excavations by dealers and collectors would be complicated in that supervision would be necessary to ensure that proper archaeological standards were observed. Strict rules would have to govern the relationship between host State

[164] Wealthy individuals would not be prevented from financing academic excavations; participating in the project and sharing in the academic results of the work with credit for what their contribution has made possible.

[165] Renfrew, C. and Bahn, P. *Archaeology: Theories, Method and Practice* (Thames and Hudson, New York, 1991): 481.

and foreign excavator: a detailed contract; deposit of performance guarantees and effective supervision of the whole process from commencement of the excavation to publication of the results.

Effective supervision of these activities requires a highly trained and incorruptible staff. Both of these are essential attributes but difficult to achieve for many States. The possibility of corruption is inevitable because of the difference between the salaries that can be paid out of the funds available and the value of many antiquities on the international market. It is obvious that a fraction of the international value of a major antiquity could be many times the yearly salary of a supervising archaeologist. And such excavations would have to be supervised by a trained archaeologist, not police or hired guards. But trained archaeologists are in short supply in many of the States likely to be affected by this proposal. If none are available the work should not begin.

> The interest in preserving archaeological evidence thus requires that the search for antiquities should be restricted to a special class of experts working under proper conditions. If the experts are unavailable, or the conditions improper, the search should simply cease.[166]

In the long term, this problem could be solved by requiring persons wishing to excavate to provide for the training of local students as archaeologists – a practice common in many countries. In the medium term, perhaps that person, as part of the cost of obtaining a contract to excavate, could be required to pay the State a sum sufficient to hire foreign archaeologists of its choice to supervise the work. But, even if this were feasible, both these options would add significantly to the costs of excavation and make the possibility of financing such excavations yet more unattractive.

For all the reasons mentioned above, States should not adopt any policy of excavating solely to provide antiquities for the trade.

Export restrictions

It will be obvious from this discussion that, if antiquities disposed of from collections; or having the character of chance finds or legally made available to the trade from excavations are to be used to increase the stock of antiquities on

[166] Bator, fn. 134, 302.

the market in the short term, it must be possible to export them. In fact, there are few countries with an absolute legal ban on the export of antiquities. On the other hand, there are a significant number which in practice do not allow their export. Export permits are either refused on a regular basis or the time taken in assessing the application for a permit is such as to deter any but the most determined. This situation is a result of administrative policy. It is not a legal problem. Certificates for export of antiquities are routinely refused in order to keep all antiquities within the country and thereby, it is argued, prevent theft and unlawful excavation. In practice, there is little evidence to suggest that either objective is achieved when determined thieves and smugglers are involved. Lowenthal sums up the situation in these words:

> Every effort to legitimize antiquities commerce for global ends inflames cultural nationalism, confirming zeal among nations rich in heritage to retain all they hold. Just as sects and ethnic minorities claim sole rights to perform or attend certain rituals, so each state sees itself the exclusively ordained guardian of the relics, institutions, legal codes, and art objects that reify its sacred traditions. Yet, as with martyrs' bodies and saints' relics in medieval times, every effort to hoard such legacies at home by prohibiting their export inflates market demand and multiplies looting, theft, and contraband trade.[167]

For most States the issue would then be one of changing policy. This will not be easy. The cavalier disregard in past years of the laws of source countries by many in the antiquities trade in market States has been an example of cultural imperialism of the very worst kind. It has left a bitter legacy of resentment. Moreover, such a change of policy could expose those espousing it to charges of selling out the national patrimony.[168] The problem is that in many States those responsible in politics and administration have convinced the public that the

[167] Lowenthal, D. *Possessed by the Past: The Heritage Crusade and the Spoils of History* (The Free Press, New York, 1996): 246.

[168] For example, note the letter from Ali Kanli, Director of the Department of Antiquities and Museums, Ministry of Education and Culture, Northern Cyprus, reproduced in (1994) *International Journal of Cultural Property* 3:169. The writer attacks the policy of the Cypriot Department of Antiquities for giving export permits for antiquities without providing any argument as to why this is wrong. It seems that his view is that the mere grant of the certificate is wrong.

safety of sites, monuments and collections is assured by ever stricter controls on excavation and movement of antiquities. But, as has been shown, these are not working: in some instances for practical reasons; in others for failure by those very people to provide adequate funds to make them work. Controls are easy to impose but difficult to enforce if there are people determined to avoid them.

Consequently, a change of policy must be preceded by education of the public: an explanation of the problems being faced and how the new policy will overcome them. This will be easier for many policy makers if they are supported by a common international approach of the type outlined above.

Changing the law

There are a number of ways in which changes to the law could assist to prevent destruction of the sources of antiquities and theft from collections. These have been outlined in a previous study.[169] Some have been taken up in the UNIDROIT *Convention on Stolen or Illegally Exported Cultural Objects* and will become part of national law for Contracting States. Here only two possibilities will be mentioned.

Limitations

As has already been mentioned,[170] there are often rules specifying that after a certain period of time no legal proceedings may be commenced to recover an object. The rationale is that there should be security in legal relations; that claims should not be allowed many years after the event when memories of what happened have faded. This is logical for normal commercial operations but becomes more complex when unique objects are concerned. The severity of the problem will depend largely on when the limitation period commences: at the time of theft? at the time one gains knowledge of the object's location? at the time demand is made for its return? at some other time?

State practice on this matter varies widely. In England, if there is a theft followed by 'conversion' (i.e. if the goods are bought by an innocent purchaser), after six years from the date of that conversion any action by the original owner is barred.[171] In France, a person other than a public authority who has had goods stolen has three years to recover them from the time they come into the

[169] Prott, L.V. and O'Keefe, P.J. *National Legal Control of Illicit Traffic in Cultural Property* UNESCO Doc. CLT-83/WS/16.

[170] See p. 41.

[171] In a recent English case, *De Préval v. Adrian Alan Ltd.* (unreported), the court held that the buyer of two unique candelabra (stolen in 1986) was not in good faith because, being a dealer with experience in the area, he should have been alerted that their provenance might be doubtful: see Redmond-Cooper, R. 'Good Faith Acquisition of Stolen Art' (1997) *Art Antiquity and Law* 2: 55.

possession of a good faith purchaser; but even then must compensate the purchaser if the goods were bought in a fair or market or from a dealer. There is a general barring of claims after 30 years.[172] In the United States of America, the matter depends on the law of its constituent states. For example, in New York state, it has been held that time does not run till demand for return has been made and refused.[173] But in other states, time dates from when the whereabouts of the object or the identity of the possessor is discovered – California has special legislation.[174]

The UNIDROIT *Convention on Stolen or Illegally Exported Cultural Objects* requires any claim for restitution of a stolen cultural object or return of an illegally exported one, to be brought 'within a period of three years from the time when the claimant knew the location of the cultural object and the identity of its possessor, and in any case within a period of fifty years from the time of the theft'.[175] A claim for restitution of a stolen cultural object forming part of an identified monument or archaeological site, or belonging to a public collection, is only subject to the three year period unless a State declares a minimum period of seventy-five years when it becomes a Party. The European Directive also has a seventy-five-year rule for public collections.

The solution adopted in the UNIDROIT Convention appears an equitable one. It is recommended that the Intergovernmental Committee for Promoting the Return of Cultural Property to Its Countries of Origin or Its Restitution in Case of Illicit Appropriation specifically endorse this and urge the Director-General to support private and public organizations seeking to bring about a uniform approach among States to limitations applying to restitution and return of cultural heritage objects, particularly antiquities.

Secrecy

Secrecy in transactions involving antiquities has already been mentioned.[176] Suggestions were there made for ways in which its abolition could be encour-

[172] O'Keefe and Prott, fn. 44, 417.

[173] *Solomon R. Guggenheim Foundation v. Lubell* 567 N.Y.S.2d 623; 569 N.E.2d 426

[174] Shapreau, C.J. 'California's Discovery Rule Is Applied to Delay Accrual of Replevin Claims in Cases Involving Stolen Art' (1996) *Art Antiquity and Law* 1: 407.

[175] Articles 3(3) and 5(5.)

[176] See p. 66.

aged. Alternatively, governments could legislate to abolish secrecy in whole or in part.

Certain of the reasons for keeping details of transactions secret have merit. For example, the persons involved do not want potential thieves to be attracted to their collections or holdings. Sometimes they do not want to attract the attention of taxation authorities – a less compelling reason. Governments need to weigh the commendable reasons against the problem of theft and destruction of the sources of antiquities. If action is decided, the next step is to determine what aspects of secrecy should be abolished and in what transactions. For example, in the context of museums, note the words of Elsen:

> Anonymity for sellers to museums is an archaic, unjustified, and outrageous anomaly.[177]

Education and publicity

In the Introduction,[178] reference was made to the need for a sustained campaign in all media highlighting the destruction caused by taking antiquities from illegitimate sources. For example, it has been suggested to the author that a series of exposés in the English media of stolen and smuggled cultural heritage has heightened public awareness of the problem in that country.

Education and publicity must cover all States affected and all levels of society. Concentration on the public in the market States is not sufficient. There must also be education of local peoples where clandestine excavation is a problem. Particular segments of society may need to be specifically targeted.

Education of professionals

Professionals concerned with antiquities – archaeologists, conservators, curators, art historians – spend many years learning their skills. But often no attention is paid to the operation of the market for antiquities; the effect demand has on collections and sites through theft and destruction; the need for standards in one's own work. Education of professionals should devote at least a modicum of time to these matters.

Groups involved in law enforcement – police, Customs officials, park rangers – should also be specifically targeted for education in their duties regarding sites and antiquities. In many cases they need to have the law explained and the problems involved in enforcing it illustrated.[179] They need to be able to recognize the type of antiquity they are likely to come across in their

[178] See p. 1.

[179] In a paper ('Consideracions sobre la protecció legal del patrimoni arqueòlogic arran del cas del Coll del Moro') the Spanish archaeologist, Hernández Herrero, describes her difficulties in persuading law enforcement officials that they were legally required to prevent metal detectorists from operating on an archaeological site she was excavating – they refused to take her complaint seriously and did not believe the men concerned were prohibited from being on the site. See *Jornades sobre protecció legal de Patrimonio Arqueòlogic: Dossier de Patrimoni Cultural* (Diputació de Barcelona, 1991): 110.

work. Officials charged with prosecutions could be helped by training in the special problems inherent in taking action on breaches of the law arising from clandestine excavation and unlawful trade.[180] Judges should be circumspectly introduced to the values underlying the legislation controlling excavation and exportation so that they do not regard the destruction of sites and monuments as 'victimless crime' to be addressed with only minimal penalties.

Education and local populations

Education of local people should begin with the professionals passing on the results of their studies. In the past this was too often ignored. Little or no attempt was made to explain the reasons for what was being done and what was hoped to be gained from it. The end result could be a conflict of interest between local peoples and professionals. For example, archaeologists have worked over many years on St. Lawrence Island off Alaska, but, at least until recently, did not explain what they were doing. The result is that:

> People frequently complain about archaeologists digging up their sites and, justifiably, about the removal of the artifacts from the island... The excavation of artifacts by archaeologists is variously presented as a cultural or a financial loss.[181]

Of Italy it has been said that many 'Tuscans regard archaeologists as total outsiders with little concern for their local heritage'.[182]

On the other hand, professionals are becoming more aware of their responsibilities. For example, the *Principles for Partnership in Cross-Cultural Human Sciences Research With a Particular View to Archaeology* state, in Paragraph 5:

[180] In the United States of America, the Federal Department of Justice and the National Park Service have developed a publication entitled *Archaeological Resources Protection: Federal Prosecution Sourcebook* which sets out the applicable Federal legislation; case reports arising from prosecutions and commentaries on the legislation. Special training courses are run for those involved in enforcing the legislation.

[181] Staley, D.P. 'St. Lawrence Island's Subsistence Diggers: A New Perspective on Human Effects on Archaeological Sites' (1993) *Journal of Field Archaeology* 20: 347, 351.

[182] Thoden van Velzen, D. 'The World of Tuscan Tomb Robbers: Living With the Local Community and the Ancestors' (1996) *International Journal of Cultural Property* 5: 111, 124.

Professionals must engage in teaching, information, and exhibition pro-
grammes designed to convey to the members of the concerned communi-
ties the significance of their cultural findings and the importance of their
preservation. Contributing to mutual understanding and respect between
cultures is an activity intrinsic to the human sciences.

The practical implementation of such a policy and its effect are illustrated by an
example from archaeologists working with the Maya.

Where involvement of the Maya in archaeological research on their past has
occurred, it has involved creation of what might be termed an information
loop, in which Maya and archaeologist work together to uncover the past
while the archaeologist learns from the excavators, where possible, about
the materials extracted from the ground. The loop then continues from the
archaeologist back to the excavators, with the result that they come to
understand more about why the work is done, what steps follow the
excavation, and how much can be learned through analysis of the material
recovered. As the fieldwork ends and excavators return to their communi-
ties, the loop ultimately extends to a wide range of Mayas without direct
involvement in archaeological work. In some circumstances the loop can be
reinforced at this point by involvement of the archaeologists themselves in
communicating research results to the communities. Although beyond
archaeologists' control, establishment of small local museums and libraries
may benefit from their assistance and add considerably to the strength of
the loop. At this level the archaeologists' involvement serves as a means of
giving the Maya specific information about their past, and also of clarifying
for them the role of archaeology in revealing the course of a long and
distinguished history from which events have largely separated them. The
failure to establish such a loop is, I submit, one of the causes of the
participation of the Maya in the sacking of their ancestral communities.[183]

As suggested, education of local peoples where there is clandestine excavation
can be an effective technique for stopping it. Of Mali, it has been said:

... the only effective way to stop the plunder of Malian antiquities is through
public education and outreach.[184]

[183] Pendergast, fn. 15, 2.

[184] McIntosh *et al.*, fn. 36, 64.

Recognizing this, scarce resources were put into a long term campaign to appeal to local pride. This was bolstered by two major monuments – Jenne and Jenne-jeno – being placed on the World Heritage List. The result has been a considerable reduction in clandestine excavations – at Jenne, in the region of 95per cent.[185] Similar success has been recorded in Peru.

> By permitting villagers to see the excavators at work, and by explaining exactly what it was that the archaeologists wanted to accomplish, Alva diffused the tensions between the two parties. Instead of posing a threat, many villagers sought to protect Huaca Rajada, and became, as one reporter called them, a 'human shield' against terrorists.[186]

Of course, education alone will not work in every situation. Sometimes local people are well aware of the value of antiquities – both historically and monetary – and yet continue to excavate. This may come from a belief or feeling that they have a right to do so.

> Grave robbers actively create a bond with their past and even claim to communicate directly with their Etruscan ancestors. They assert that financial gain is not the main motivation behind their work, but that they are driven by an affinity with their forebears which develops during their nocturnal excavations. Other Tuscans do not abstain from such interpretations… [187]

Sometimes local people may feel they have no other way of gaining an adequate living or the antiquities may be of a race, period or religion which they do not see as having any importance to their own lives. To meet these situations education may need to be combined with some other factor such as income substitution or planned involvement in the archaeological work.[188]

[185] Fn. 184, 66.

[186] Kirkpatrick, S.D. *Lords of Sipan: A True Story of Pre-Inca Tombs, Archaeology, and Crime* (William Morrow, New York, 1992): 148.

[187] Thoden van Velzen, fn. 182, 124.

[188] Fn. 182, 125; also UNSDRI *The Protection of the Artistic and Archaeological Heritage: A View from Italy and India* (UNSDRI, Rome, 1976 – Publication No.13).

Education of the public

Involvement of the public in, and interaction with, the archaeological process is now widely recognized. The *Principles for Partnership in Cross-Cultural Human Sciences Research With a Particular View to Archaeology* state, in Part C, Paragraph 16:

> Archaeologists shall inform the general public within the host country as early as possible by all suitable means (including publication, presentation, and through the mass media, lectures and guided visits) of the existence and, later, the results of an archaeological campaign.

Involvement of the public in the archaeological process is endorsed by the international community. Article 9 of the *European Convention on the Protection of the Archaeological Heritage (Revised)* 1992 deals with the 'Promotion of Public Awareness' and requires each State Party to 'promote public access to important elements of its archaeological heritage, especially sites'. Similar is Article 12 of the 1956 UNESCO *Recommendation on international principles applicable to archaeological excavations*:

> In order to encourage the public to visit these [archaeological] sites, Member States should make all necessary arrangements to facilitate access to them.

Part of the protective mantle can be cast in terms of national pride. This is not something restricted to developing countries. In Denmark, for example, it has been used for this purpose for more than a century.

> ... it should be realized that archaeology in Denmark was always national in character, forming an important part of national history and ideology. As such it may be regarded as a scientific extension of earlier national mythology. Since the early nineteenth century archaeology has indirectly been used by rising and dominating groups to support and legitimize their policy[189]

In Greece antiquities have had a long and continuing role in the political process.

[189] Kristiansen, K. 'Denmark' in Cleere, H. *Approaches to the Archaeological Heritage* (Cambridge University Press, Cambridge, 1984): 21, 33.

Antiquity, playing a crucial role in modern Greek society, is constantly used by the state, by different interest groups and by individuals for a variety of purposes. The construction of national identity is one such purpose.[190]

National pride may also be enhanced by archaeology on relatively recent sites.

... the nation building use of archaeological data even occurs in countries, like the United States, that lack an ancient history or a direct link with the prehistoric past; the concept of 'ancient-ness' is relative and 'may lie in the eye of the beholder,'... [191]

Education of special groups

It may be necessary to target particular groups that are causing destruction of the archaeological record. For example, in some countries metal detecting is a significant problem. On the one hand, the extraction of metal antiquities found by the detector destroys the context; if the find is not recorded and the object goes into a private collection then that clue to the past is lost. On the other hand, the English Heritage sponsored Report on the matter suggests that users of the machine have bought considerable benefits to archaeology when finds have been recorded. Moreover, the sheer number of users has meant that the volume of finds and their contribution to knowledge is much greater than could have been done by archaeologists operating under normal conditions. There has certainly been publicity on the issue and the Report states that much 'more work can be done on building relationships with hobbyists, to persuade them to record their findspots and report their finds'.[192] It should be noted that here the analysis concerns hobbyists and not thieves or those 'metal-detecting groups of forty individuals arriving in an area, then blowing up everything for speed and sweeping up the debris'.[193]

[190] Hamilakis, Y. and Yalouri, E. 'Antiquities as Symbolic Capital in Modern Greek Society' (1996) *Antiquity* 70: 117, 127.

[191] Kohl, P.L. and Fawcett, C. 'Archaeology in the Service of the State: Theoretical Considerations' in Kohl, P.L. and Fawcett, C. (eds.) *Nationalism, Politics, and the Practice of Archaeology* : 3, 4.

[192] Dobinson and Denison, fn. 37, xi.

[193] Melikian, fn. 28, 27.

Publicity

In addition to explaining the role of archaeology; its possible contribution to the welfare of local people and the edification of the public in general, there must be extensive publicity on the damage caused by destruction of the sources of antiquities and theft from collections. Part of the publicity can be an exposé of what is happening but there needs to also be an educative element – it should be explained why this destruction is so significant and why it must be stopped. Part of the publicity will have to be directed at local populations but the greater effort must be in the market States where the demand that fuels the destruction originates. Television programmes seem to be particularly successful in this.

In all publicity praise should be given to that person who has been called the 'Good Collector'.[194] In summary, such a collector uses the collection to expose others to the culture of the creators of the antiquities and employs the collection for the advancement of knowledge. He or she rejects any notion that aesthetic considerations justify the destruction of the archaeological context and, further, is willing to publicly oppose destruction of the sources of antiquities.[195] Weil speaks of this collector in the following words:

> What is meant by the need of the ideal collector to collect in an ethical fashion? Something more than that he or she obey the applicable (and considerable) laws that affect the art trade and refrain from sharp practices in transactions with dealers and others. At its ideal level, collecting ought to be restricted to objects already in legitimate public circulation. What it must avoid are those objects that can be obtained only through the destruction of their original context. Here some equivalent of the Hippocratic Oath might be in order. Do no harm. Or considering the damage already done by the despoliation of historical and cultural sites, do no further harm. To serve as an ideal specimen, the private art collector must be prepared to put humankind's need to preserve the past above his or her own impulse to possess its fragments.[196]

[194] McIntosh *et al.*, fn. 36, 60.

[195] The full text of this characterization is set out in Appendix VIII.

[196] Weil, S.E. 'Collecting a Private Collector: In Search of the Ideal' in Weil, S.E. *A Cabinet of Curiosities: Inquiries Into Museums and Their Prospects* (Smithsonian Institution Press, Washington, 1995): 133, 136.

UNESCO support

In recent years UNESCO has held a number of educational workshops in different regions in conjunction with specialist nongovernmental organizations. For example, with the South Pacific Asian Forum (SPAFA) at Jomtien, Thailand (1993) for Asian countries; with the Hungarian National Commission for UNESCO at Keszthély, Hungary (1993) for Eastern and Central Europe; with ICOM at Arusha, Tanzania (1993) for Southern and Western Africa; with ICOM at Bamako, Mali (1994) for Eastern Africa; with ICOM at Cuenca, Ecuador (1995) for Latin America; with the International Committee of the Red Cross at Tashkent, Uzbekestan (1995) for Central Asian countries. A workshop conducted by UNESCO alone was held in Grenada for the Caribbean region in March 1997. ICOM has played a role through its publication with the financial support of UNESCO of two books detailing missing objects of the cultural heritage: *One Hundred Missing Objects from Angkor* and *One Hundred Missing Objects: Looting in Africa*. Many of the objects listed are antiquities. The current locations of some objects has been established and their return has been negotiated or is being negotiated. A further book relating to missing objects from South America is in preparation. As part of the publicity drive, UNESCO has produced posters and is currently preparing a Manual on how to conduct a national workshop on the control of unlawful traffic. It is vital that these activities by UNESCO and ICOM continue.

UNESCO should take an even more active role in the educational process outlined above. For example, it could act as a resource base providing a library of materials on which States could draw for their educational campaigns. Such resources would include, for example, a slide collection, books, brochures, posters. Mention has already been made of television programmes detailing the destruction of sites and monuments and exposing those involved in unlawful trade. These have proved very effective in educating the public. But once shown they are often difficult to obtain, particularly by persons in other countries. UNESCO could deliberately seek out these films to form an invaluable resource collection. Hopefully, permission could be obtained to copy them for distribution for educational purposes. Similarly, a collection of books and articles dealing with the issues discussed in the preceding pages could be formed.

Samples of State action to reduce destruction of sites and monuments should be sought, recorded and information disseminated. For example, some

administrations have been experimenting with the use of local volunteers to keep watch on designated archaeological sites. There are considerable variations in how this is done and the degree of formality. UNESCO could gather information on these programmes and assess how they work in practice. This would be very useful information for other administrations in their fight against clandestine excavation.

UNESCO could also commission the preparation of special kits for those involved in educational campaigns. Drawing on the expertise of those already successful in the field, these could be used to plan such campaigns. They could contain materials available for copying by the officials and teachers concerned and used for teaching purposes.

UNESCO should collect evidence showing the difference in price between antiquities with a provenance and those without. Several examples of the effect the absence of provenance has on market value have been given. But more examples and statistics are needed. Once they are obtained, UNESCO should publicize the differential as widely as possible in order to fix the fact firmly in the mind of the public, particularly those interested in buying antiquities.

Codes of ethics

More attention should be given to publicizing the codes of ethics adopted by dealers, museums and professional bodies. In part this has an educative effect and in part it puts people on notice as to what conduct is unacceptable; even by those outside the organizations concerned.

If dealers' codes are to be subjected to quasi-legal interpretation, then more care has to be taken in their drafting. In the ideal world, one would hope that those who have agreed to abide by a code would attempt to conform to its spirit and not take action based on nice distinctions. But experience proves that the ideal does not match reality and careful drafting is needed.

A matter which dealers should also consider for their codes of ethics is that of reporting offers to the police. It appears that some dealers, while they will not buy stolen antiquities, do not consider it necessary to report the offer to the police as it would jeopardise a 'source'.[197] Failure to do so encourages further theft and destruction of the sources of antiquities. Associations should stipulate

[197] Ellis, fn. 88, 223.

that members have a duty to report these offers. For example, auctioneers in Norfolk, England, acting in conjunction with the Norfolk police and the Council for the Prevention of Art Theft, have adopted a *Policy of Due Diligence*. After providing that they will refuse to buy, sell or value an antique or piece of fine art they believe to be stolen, the Policy goes on to say that they will, if uncertain, contact the police and attempt to retain the item while enquiries are made. Furthermore, they will 'attempt to gather information which may help the Police to identify the person(s) in possession of such items'.

Museums could play a more active role in the fight against destruction and theft. Exhibitions in the market countries showing the damage caused could be one way of doing this. But, in addition, museums could do more to publicize their codes of ethics whereby they refuse to collect objects with inadequate provenance or to accept them as loans. There are reports that some museums regard these codes as private documents and not to be revealed to enquirers. This is totally unacceptable as far as their attitude to unprovenanced antiquities is concerned and should be resisted by the museum community.

> Many museums have often hushed up the matter of illicit traffic. Bringing the discussion into the open should not be regarded as offensive. If by subjecting their acquisitions of material culture to strict restrictions the museums reduce the number of objects they acquire, they should remember they are contributing to a better mutual understanding between museums in Western countries and museums in developing countries.[198]

Greater publicity given to collecting policies may also encourage resistance on the part of those museum officials tempted to succumb when offered a particularly significant antiquity of doubtful provenance.

Investigations

The trade in antiquities from clandestine excavations, monuments and theft is murky. Little is known of how it operates although investigative reporting in recent years has revealed small segments of it. As part of the publicity directed to the subject, UNESCO should finance and arrange for investigation into the actual working of this trade – how it operates, who is involved, where the money

[198] Leyten, H. 'Illicit Traffic and the Collections of Western Museums of Ethnography' in Leyten, H. (ed.) *Illicit Traffic in Cultural Property: Museums Against Pillage* (Royal Tropical Institute, Amsterdam, 1995): 14, 23.

comes from etc. If this were done, and examples show it can be done, then the resultant publicity may well force some of it out of existence. Certainly, newspapers and other media would be most interested in the product of such investigations if it were properly done. This proposal concerns investigative reporting and not, for example, something in the nature of police work. The persons involved would need to have a high commitment to the project and a wide knowledge of international relations and culture.

These high profile investigations have the potential to stop a great deal of such trade. But oversight at a more basic level is also essential as part of the general need to gather and disseminate information. Here private bodies could play a most significant role if they so chose. For example, following a seminar on the unlawful trade in antiquities from the Middle East, held at the McDonald Institute of Archaeological Research, University of Cambridge, in May 1995, the Institute has plans to issue an informal six-monthly Newsletter on the subject, beginning in 1997. It will gather news of looting and theft; report on events in the markets and auction houses; on activity by the media and law enforcement agencies, and cover national and international legal issues, while offering an opportunity for an exchange of views.[199] The Society for the Preservation of Afghanistan's Cultural Heritage (SPACH) publishes a newsletter detailing acts of destruction affecting collections and archaeological sites in that country as well as the trade in antiquities taken from both. Other bodies may be prepared to strengthen these initiatives by providing information and assistance. One can envisage a network of similar institutions pooling their resources to provide greater and more efficient coverage. Once again, the publicity so generated could work effectively against the unlawful trade in antiquities.

Co-operation

As part of the formulation of a common approach to the issues involved in preventing the destruction of sites and monuments and theft from collections, it is absolutely essential that dealers, auction houses, archaeologists, collectors (both public and private) and government officials come together in a spirit of cooperation. While the Intergovernmental Committee for Promoting the Return

[199] Further information can be obtained from the Director, The McDonald Institute for Archaeological Research, CAMBRIDGE CB2 3ER, England.

of Cultural Property to Its Countries of Origin or Its Restitution in Case of Illicit Appropriation can encourage the various parties involved, it is not the appropriate body to do this. It does not meet sufficiently often and is not representative of all the parties involved. It would be desirable for formulation of the approach to take place in a non-partisan atmosphere. One of the large international foundations might be willing to provide the facilities for such meetings. The Bellagio Conference Centre in Italy run by the Rockefeller Foundation would appear to be an ideal centre.

It would be highly desirable that during this period all participants refrain from inflammatory and/or misleading statements. The process would be advanced if this extended beyond the immediate participants to others who would benefit from the meetings. Dealer associations could ask their members to refrain from attacking the current policies of foreign governments. Those governments could tone down their press releases regarding material found in other countries and be scrupulous in their handling of enquiries.[200] Reporting must be fair, unbiased[201] and accurate.[202] The proposed changes can only be brought about by good will and honesty on the part of all those involved. All will be called to give up something but all will gain if the destruction of sites and monuments and theft from collections can be reduced.

If a dialogue could be initiated and sustained, it might be possible to set up a foundation formalizing the process of consultation. This would ensure continuity in relationships and policy formulation; assist with information distribution and allow concerted engagement in the educative process.

[200] Ede records an episode where a request for information brought an immediate and unsubstantiated demand for return of the object which later turned out to have been legally exported: Ede, J. 'The Antiquities Trade: Towards a More Balanced View' in Tubb: fn. 12, 211, 212.

[201] An example of slanted reporting appears in the *ARTnewsletter* of 12 December 1995 at p.6 where the views of one James Fitzpatrick are quoted with no mention that they were soundly criticized by other speakers at the same meeting.

[202] An example is an article entitled 'They're Out to Steal Our Stolen Art' published in the *Daily Telegraph*, 2 May 1995, which is so full of inaccuracies and mistakes as to be irresponsible.

Primacy of information retrieval

Although the trade in antiquities is a very old one, this does not mean that it and those who benefit from it have overriding interests. States need to make clear that the primary value of an antiquity lies in the information it can impart on the history of humanity. The perception that 'governments sometimes seem to be more interested in having antiquities within their own borders than in protecting the archaeological context'[203] must be dispelled. If the antiquity has an aesthetic, as well as an archaeological value, that is to be welcomed but it is of secondary importance.

Merryman has suggested that the interests of archaeologists should not be regarded as superior to that of collectors and the art trade.[204] But here it is argued that this is not a contest between archaeologists on the one side and art historians, collectors and dealers on the other. The public has an interest in the preservation of information; in education and in leisure enhanced by access to all cultures. These interests can be met, but only with proper treatment of antiquities which are available to the present generation by chance. They have survived the myriad possibilities of destruction through the ages to tell the story of their makers to those who can read it. In many cases they are all the record that humanity has of its origins in a particular part of the world. Consequently, any deliberate destruction of the historical value of an antiquity is, if not yet legally at least morally, a crime against humanity. Moreover, it must be stated that inadequate performance of their professional roles by those who deal with these remains of the past is as reprehensible as destruction of the historical context.

The public interest also requires that the maximum historical information should be able to be extracted from the antiquity. This means study of it in context and afterwards.

[203] Cook, fn. 60, 190.

[204] Merryman, J.H. 'Archaeologists Are Not Helping' The *Art Newspaper*, No. 55, January 1996, 26; see also Merryman, J.H. 'The Antiquities Problem' (1995) *Public Archaeology Review* (December): 10 .

Thirdly, there must be public access to important antiquities for both research and general informational purposes. Public ownership is not necessary as long as access is ensured.

When these conditions are satisfied, then the interest in exchange and transfer can be dealt with. As has already been said, the interests of dealers and collectors can be accommodated in a reasonable framework set out in the previous pages while lessening destruction and loss of information.

Conclusion

Effectively accommodating the interests of those involved with antiquities and their context; preventing the destruction of sources; reducing theft from collections: all these require a unified approach utilizing the suggestions outlined in these pages. Concentration on one set of interests alone will be counter-productive.

For example, education and publicity will not work unless there are clear and effective laws underlying the policies that are being projected. Law itself is part of the educative process and must receive support from those it affects. Policies restricting the ability of finders to clandestinely dispose of antiquities should be counterbalanced by others dealing with rewards and encouragement to report finds.

The proposal to diminish the demand for unprovenanced antiquities in the Report relies on two mechanisms: an increase in provenanced antiquities in the short term and education to reduce demand for unprovenanced antiquities in the long term. Unless these educational measures are taken immediately by all States concerned, increasing the flow of antiquities in the short term may only increase the general demand for them, provenanced or not. Moreover, those States which will be the major source of any additional antiquities for the market are not likely to act unless they see institutions in the major market countries do the same and that an effective educational campaign is financed in those countries to reduce demand for unprovenanced antiquities. The long term plan should enable collectors and dealers to foresee changes in the market and reorganize their operations.

States will be required to take action in a number of fields. If they are persuaded by the arguments used in this report they should: make specific declaration that the primary value of antiquities lies in the information that they can impart as regards humanity's past; adopt and implement up-to-date legal controls on excavation, export and acquisition of antiquities; stress the importance, in their bilateral negotiations, of all States participating in the UNESCO *Convention on the Means of Prohibiting and Preventing the Illicit Import,*

Export and Transfer of Ownership of Cultural Property 1970; become party to the UNIDROIT *Convention on Stolen or Illegally Exported Cultural Objects* 1995; study national law on ownership of undiscovered antiquities, noting that claims to State ownership are acceptable to the international community and may even be a duty, with a view to ensuring that national law on this point is clear and unambiguous; ensure that actions in foreign courts to enforce claims for recovery of antiquities owned by the State be brought with care and be well prepared; encourage the development and, more importantly, the observance of codes of practice by all affected by the antiquities trade; ensure that, when taxation benefits are allowed for donations of antiquities, the provenance of the object must be made public and must not show any taint of illicit trafficking; set a date from which provenance must be ascertained for any transaction to be valid; investigate the possibility of differential rates of taxation applying to transactions in antiquities depending on the degree of secrecy involved; consider the possibility of taking action to increase the flow of antiquities onto the market from legitimate sources; emphasize the importance of paying rewards to those who report chance finds; return to the finder unwanted antiquities and, when it is necessary to undertake archaeological excavations, doing so in such a way as to least inconvenience the occupier of the land; consider relaxing the implementation of export restrictions so as to allow free transit of antiquities obtained from chance finds and returned to the finder or any that are assessed as being of insufficient value to be kept in official collections; assess whether current law on time limitations and secrecy is helping or hindering the fight against theft and the destruction of the sources of antiquities.

UNESCO has a major role to play. It must coordinate State action on the matters outlined above and elsewhere in this Report. In many cases UNESCO will have to initiate that action and give it concrete form whether by international convention or Recommendation. This will require devotion of much greater resources to the fight against theft and the destruction of the sources of antiquities and their context than is currently the case. Platitudes are not enough. UNESCO and its Member States will not be regarded as serious in this fight unless they are prepared to take substantial initiatives. More specifically, the Organization's activities in education as outlined in this Report must be enhanced. It should act as a resource centre; commission investigative reporting on the unlawful trade in antiquities; collect evidence on price differentials in the trade of antiquities; take an active role in disseminating information on codes of

ethics and practice affecting trade in antiquities and collect information on lapses from the recommended standards; support the development of existing electronic databases carrying information on the trade in antiquities; encourage a dialogue between dealers, auction houses, archaeologists and government officials to formulate a common approach to implementation of policy.

The Intergovernmental Committee for Promoting the Return of Cultural Property to Its Countries of Origin or Its Restitution in Case of Illicit Appropriation has both an active and watchdog role. It should monitor how States are implementing the proposals that are adopted. It should also be responsible for selecting members of the committee to establish whether there are collections of antiquities which could be released onto the market and whether the development of a policy to this effect is desirable. It should consider endorsement of the core data standards for identification of stolen objects and promotion of them throughout the world.

This Report has tried to state and analyse all the arguments about the trade and traffic in antiquities. Not all these arguments are realistic, but all need to be given a hearing and explanations set forth when they are not acceptable, as why. A new approach to a complex problem can be tried, but it will need co-operation from all parties.

Much has survived of humanity's past. Much of it we know. Much we have yet to discover. That can only be done if we strive to preserve all that is important. Surely it is not beyond the ability of us all to co-operate in this work.

Selected bibliography

Ardouni, C.D. 'Vers un trafic licite des biens culturels' (1995) *International Journal of Cultural Property* 4: 91.

Association Henri Capitant (ed.) *La protection des biens culturels* (Economica, Paris, 1991).

Batievsky, J. 'The Protection of Pre-hispanic Cultural Property in Peru' paper presented at 12th Section on Business Law Biennial Conference, Paris, 17–22 September 1995.

Bator, P.M. 'An Essay on the International Trade in Art' (1982) *Stanford Law Review* 34: 275.

Belk, R.W. *Collecting in a Consumer Society* (Routledge, London, 1995).

Briat, M. and Freedberg, J.A. *Legal Aspects of International Trade in Art* (ICC Publishing, Paris; Kluwer, The Hague; 1996).

Broadman, J. 'Don't Just Berate the Thieves: Look at the Museums and Excavators Too' The *Art Newspaper*, No. 54, December 1995: 20 and 38.

Byrne-Sutton, Q. *Le trafic international des biens culturels sous l'angle de leur revendication par l'Etat d'origine* (Schulthess Polygraphischer Verlag, Zurich, 1988).

Byrne-Sutton, Q. and Renold, M-A. (eds.) *La libre circulation des Collections d'objets d'art* (Schultess Polygraphischer Verlag, Zurich, 1993).

Byrne-Sutton, Q. and Renold, M-A. (eds.) *Les objets d'art dans l'Union Européenne* (Schultess Polygraphischer Verlag, Zurich, 1994.)

Cannon-Brookes, P. 'Antiquities in the Market-place: Placing a Price on Documentation' (1994) *Antiquity* 68: 349.

Chippindale, C. 'Commercialization: The Role of Archaeological Laboratories and Collectors' (1993) *Antiquity* 67: 699.

Cleere, H. *Approaches to the Archaeological Heritage* (Cambridge University Press, Cambridge, 1984).

Cocks, A.G.S. 'A Dangerously Politicised Issue, Its Laws Obsessed With the Objects Rather Than the Sites' The *Art Newspaper*, No. 52, October 1995: 27.

Coggins, C.C. 'A Licit International Traffic in Ancient Art: Let There Be Light' (1995) *International Journal of Cultural Property* 4: 61.

Cook, B.F. 'The Transfer of Cultural Property: British Perspectives' in *Eredita Contestata? Nuove prospettive per la tutela del patrimonio archeologico e del territorio* (Accademia nazionale dei lincei, Rome, 1992): 15.

Council of Europe *The Art Trade* (1988) Report of the Committee on Culture and Education, Parliamentary Assembly Doc. 5834.

Coutau-Bégarie, H. and Schmitt, J-M. (eds.) *Le patrimoine mobilier: Quelle politique européenne?* (Economica, Paris, 1990)

Decker, A. 'Lost Heritage: The Destruction of African Art' (1990) *ARTnews* 89 (September): 108.

Dobinson, C. and Denison, S. *Metal Detecting and Archaeology in England* (English Heritage, London, 1995)

Elia, R. 'The World Cannot Afford Many More Collectors With a Passion for Antiquities' The *Art Newspaper*, No. 41, October 1994: 19.

Fechner, F. *Rechtlicher Schutz archäologischen Kulturguts: Regelungen im innerstaatlichen Recht, im Europa- und Völkerrecht sowie Möglichkeiten zu ihrer Verbesserung* (Duncker and Humblot, Berlin, 1991).

Fechner, F., Opperman, T. and Prott, L.V. (eds.) *Prinzipien des Kulturgüterschutzes: Ansätze im deutschen, europäischen und internationalen Recht* (Duncker and Humblot, Berlin, 1996).

Fraoua, R. *Le trafic illicite des biens culturels et leur restitution* (Editions Universitaires, Fribourg, 1985).

Frigo, M. *La protezione dei beni culturali nel diritto internazionale* (Dott. A. Giuffrè Editore, Milan, 1986).

Fuentes Camacho, V. *El trafico ilicito internacional de bienes culturales* (Editorial Beramar, Madrid, 1993).

Gill, D.W.J. and Chippindale, C. 'Material and Intellectual Consequences of Esteem for Cycladic Figures' (1993) *American Journal of Archaeology* 97: 601.

Gimbrere, S. and Pronk, T. 'The Protection of Cultural Property: From UNESCO to the European Community With Special Reference to the Case of the Netherlands' (1992) *Netherlands Yearbook of International Law* 23: 223.

Greenfield, J. *The Return of Cultural Treasures* (Cambridge University Press, Cambridge, 1989).

Griffiths, T. *Hunters and Collectors* (Cambridge University Press, Melbourne, 1996).

Hoving, T. in *The Chase, the Capture: Collecting at the Metropolitan* (Metropolitan Museum of Art, New York, 1975).

Hunt, S.; Jones, E.W. and McAllister, M.E. *Archaeological Resource Protection* (Preservation Press, Washington, 1992).

Institute of Art and Law *Title and Time in Art and Antiquity Claims* Papers from a Seminar held in London on 13 November 1995 (Institute of Art and Law, Leicester, 1995).

Institute of Art and Law *Art Export Licensing and the International Market* Papers from a Seminar held in London on 19 March 1996 (Institute of Art and Law, Leicester, 1996).

International Council of Museums *Illicit Traffic of Cultural Property in Africa* (International Council of Museums, Paris, 1995).

Jornades sobre protecció legal de Patrimonio Arqueologic: Dossier de Patrimoni Cultural (Diputació de Barcelona, 1991)

Kassimatis, G. (ed.) *Archaeological Heritage: Current Trends in Its Legal Protection* (Sakkoulas Bros., Athens, 1995).

Kirkpatrick, S.D. *Lords of Sipan: A True Story of Pre-Inca Tombs, Archaeology, and Crime* (William Morrow, New York, 1992).

Leyten, H. (ed.) *Illicit Traffic in Cultural Property: Museums Against Pillage* (Royal Tropical Institute, Amsterdam, 1995).

Lowenthal, D. *The Past is a Foreign Country* (Cambridge University Press, Cambridge, 1985).

Lowenthal, D. 'Conclusion: Archaeologists and Others' in Gathercole, P. and Lowenthal, D. (eds.) *The Politics of the Past* (Unwin Hyman, London, 1990): 302.

Lowenthal, D. *Possessed by the Past: The Heritage Crusade and the Spoils of History* (The Free Press, New York, 1996).

Lynott, M.J. and Wylie, A. *Ethics in Archaeology: Challenges for the 1990's* (Society for American Archaeology, Washington, 1995).

Maurice, C. and Turnor, R. 'The Export Licensing Rules in the United Kingdom and the Waverley Criteria' (1992) *International Journal of Cultural Property* 1: 273.

McIntosh, R.J.; Togola, T. and McIntosh, S.K. 'The Good Collector and the Premise of Mutual Respect Among Nations' (1995) *African Arts* (Autumn): 60.

Melikian, S. 'A Degree of Destruction Unprecedented in the History of the World – And Yet I Support Collecting' The *Art Newspaper*, No. 52, October 1995: 27.

Merryman, J.H. 'Two Ways of Thinking About Cultural Property' (1986) *American Journal of International Law* 80: 831.

Merryman, J.H. 'The Public Interest in Cultural Property' (1989*) California Law Review* 77: 339.

Merryman, J.H. 'The Nation and the Object' (1994) *International Journal of Cultural Property* 3: 61.

Merryman, J.H. 'A Licit International Trade in Cultural Objects' (1995) *International Journal of Cultural Property* 4: 13.

Merryman, J.H. 'Archaeologists Are Not Helping' The *Art Newspaper*, No. 55, January 1996: 26.

Messenger, P.M. (ed.) *The Ethics of Collecting Cultural Property: Whose Culture? Whose Property?* (University of New Mexico Press, Albuquerque, 1989).

Meyer, K.E. *The Plundered Past: The Traffic in Art Treasures* (Readers' Union, London, 1974).

Muensterberger, W. *Collecting: An Unruly Passion: Psychological Perspectives* (Princeton University Press, Princeton, 1994).

Murphy, J.D. 'The Imperilment of Cultural Property in the People's Republic of China' (1995) *University of British Columbia Law Review* (Special Issue): 91.

Murphy, J.D. *Plunder and Preservation: Cultural Property Law and Practice in the Peoples' Republic of China* (Oxford University Press, Hong Kong, 1995).

Nafziger, J.A.R. 'Regulation by the International Council of Museums: An Example of the Role of Non-Governmental Organizations in the Transnational Legal Process' (1972) *Denver Journal of International Law and Policy* 2: 231.

Nafziger, J.A.R. 'International Penal Aspects of Protecting Cultural Property' (1985) *International Lawyer* 19: 835.

O'Keefe, P.J. and Prott, L.V. *Law and the Cultural Heritage: Volume I; Discovery and Excavation* (Butterworths, London, 1984).

O'Keefe, P.J. and Prott, L.V. *Law and the Cultural Heritage: Volume III: Movement* (Butterworths, London, 1989).

O'Keefe, P.J. 'Protection of the Material Cultural Heritage: The Commonwealth Scheme' (1995) *International and Comparative Law Quarterly* 44: 147.

O'Keefe, P.J. 'Provenance and Trade in Cultural Heritage' (1995) *University of British Columbia Law Review* (Special Issue): 259.

Ortiz, G. 'In Pursuit of the Absolute' in *In Pursuit of the Absolute: Art of the Ancient World From the George Ortiz Collection* (Royal Academy of Arts, London, 1994)

Palmer, N.E. 'Treasure Trove and Title to Discovered Antiquities' (1993) *International Journal of Cultural Property* 2: 275.

Pearce, S.M. *On Collecting: An Investigation Into Collecting in the European Tradition* (Routledge, London, 1995)

Pendergast, D.M. 'Looting the Maya World: The Other Losers' (1994) *Public Archaeology Review* 2 (September): 2.

Prott, L.V. and O'Keefe, P.J. *National Legal Control of Illicit Traffic in Cultural Property* (UNESCO Doc. Clt-83/WS/16, 1983).

Prott, L.V. and Specht, J. (eds.) *Protection or Plunder: Safeguarding the Future of Our Cultural Heritage* (Australian Government Publishing Service, Canberra, 1989).

Prott, L.V. and O'Keefe, P.J. *Handbook of National Regulations Concerning the Export of Cultural Property* (UNESCO, Paris, 1988).

Prott, L.V. 'Problems of Private International Law for the Protection of the Cultural Heritage' (1989) *Recueil des cours de l'Académie de Droit International* 217: 219.

Rijn, M. van *Hot Art, Cold Cash* (Little Brown and Co., London, 1993)

Schmidt, P.R. and McIntosh, R.J. (eds) *Plundering Africa's Past* (Indiana University Press, Bloomington, 1996).

Siehr, K. 'International Art Trade and the Law' (1993) *Recueil des cours de l'Académie de Droit International* 243: 13.

Silverman, H. 'Who Owns the Past?: The Potential Privatization of Archaeology in Peru' (1993) *Public Archaeology Review* 1: 1.

Smith, G.S. and Ehrenhard, J.E. (eds.) *Protecting the Past* (CRC Press, Boca Raton, Florida, 1991).

Staley, D.P. 'St. Lawrence Island's Subsistence Diggers: A New Perspective on Human Effects on Archaeological Sites' (1993) *Journal of Field Archaeology* 20: 347.

Taylor, P.M. (ed.) *Fragile Traditions: Indonesian Art in Jeopardy* (University of Hawaii Press, Honolulu, 1994).

Thornes, R. 'Protecting Cultural Objects Through International Documentation Standards: A Preliminary Survey' (Getty Art History Information Program, J. Paul Getty Trust, Santa Monica, 1995).

True, M. and Kozloff, A. 'Barbara and Lawrence Fleischman: Guardians of the Past' in Harris, J. (ed.) *A Passion for Antiquities: Ancient Art from the Collection of Barbara and Lawrence Fleischman* (The J. Paul Getty Museum, Malibu, 1994).

Tubb, K.W. (ed.) *Antiquities: Trade or Betrayed: Legal, Ethical and Conservation Issues* (Archetype, London, 1995).

Tubb, K.W. and Sease, C. 'Sacrificing the Wood for the Trees – Should Conservation Have a Role in the Antiquities Trade?' in Roy, A. and Smith, P. (eds.) *Archaeological Conservation and Its Consequences* (International Institute for Conservation of Historic and Artistic Works, London, 1996).

UNSDRI *The Protection of the Artistic and Archaeological Heritage: A View from Italy and India* (UNSDRI, Rome, 1976 – Publication No.13).

Vitelli, K.D. 'A Case Study in Archaeological Context: Palaeolithic Obsidian from Franchthi Cave' in Vitelli, K.D. (ed.) *Archaeological Ethics* (AltaMira, Walnut Creek, California, 1996).

Walden, D.A. 'Canada's Cultural Property Export and Import Act: The Experience of Protecting Cultural Property' (1995) *University of British Columbia Law Review* (Special Issue): 203.

Watson, P. *Sotheby's: Inside Story* (Bloomsbury, London, 1997).

Weihe, H.K. 'Licit International Traffic in Cultural Objects' (1995) *International Journal of Cultural Property* 4: 81.

Citations to further reference material can be found in *the Bibliographic Database on Heritage Law* from Canadian Heritage Information Network, Department of Canadian Heritage, 15 Eddy Street, 4th Floor, Hull, Quebec K1A 0M5, Canada, or through Client Services on (819) 994 1200 or e-mail at service@chin.gc.ca.

Appendix I

Extract from Walden, D.A. 'Canada's Cultural Property Export and Import Act: The Experience of Protecting Cultural Property' (1995) (Special Issue) *University of British Columbia Law Review* 203: 214–16.

1. *Goodwill is not enough.* It is not sufficient for a country to merely enact legislation protecting domestic and foreign cultural property, nor can the requesting State merely assert ownership and request its return. Considerable time and expense is required by both parties to establish when the export took place, if the objects in question are subject to export restrictions and if an international convention applies. While this information is often extremely difficult to obtain, it is essential before any legal action for the return of the cultural property can be initiated.

2. *Different languages and differing cultural values can both pose practical and legal problems.* The approach to cultural property protection by the so-called 'exporter countries' is different than [*sic*] that of western countries and this can lead to political, evidentiary and procedural difficulties. Requiring the use of translators during lengthy court proceedings, for example, slows proceedings, frustrates judges and dulls the impact of the witnesses' testimony.

3. *Appropriate storage facilities and adequate security are essential but difficult to find.* Cultural property, which requires museum-standard light levels and humidity and temperature controls, cannot be stored in the warehouse facilities normally used by Customs or law enforcement officials. It must also be recognized that the cultural property may be in storage for years and the costs associated with specialized storage facilities can be extremely high.

There is also the requirement that seized objects be under the constant control of law enforcement officials. Moving the cultural property to a facility with appropriate environmental controls, therefore, may present legal problems if 'continuity' in the seizure is not maintained. Furthermore, there are both legal and moral obligations to ensure that the cultural property is returned – to the importer if the legal proceedings are unsuccessful or the country of origin if they are successful – in the same condition it was in at the time it was seized.

4. *Finding appropriate experts, often on short notice, to identify and authen-*

ticate the cultural property can be problematic. Further problems can be encountered when experts are advised that they may be required to present their evidence in a court of law. Many experts are reluctant to become involved in lengthy legal proceedings that will take them away from other duties – sometimes for weeks or months at a time – and that will challenge their academic credentials. If the fair market value of the cultural property is an issue, valuation experts may also be required, as academics and museum personnel are often reluctant to provide information about monetary value.

5. *Actions to recover cultural property are expensive.* This should not be used as an excuse for inaction, but it is a reality. The budgets of government organizations do not have the flexibility to absorb unanticipated expenses and the expenditure reductions that have been implemented by governments around the world have also affected the financial resources available for the protection of cultural property. Legal, technical and curatorial experts can charge high fees and must also be reimbursed for travel and accommodation expenses. If an expert witness is required to be available to testify for a period of weeks or even months, they may only agree to do so if they will be compensated for the loss of other real or potential income.

6. *Bureaucracies don't move quickly* – whether they are in 'the importing country' or the requesting state. The need to involve several government departments in both countries takes time and in some cases can lead to 'turf wars' while it is decided which department has the responsibility for ensuring the return of the cultural property. Discussions with the requesting states often take place through embassies and rely on a middle-person to relay requests for information to the home government. Language differences and problems comprehending the complex technical or subtle legal information required may mean that the same request has to be made several times.

7. *Central coordination of activities is essential.* One responsibility centre must be established to coordinate all of the activities associated with cultural property protection. This can be difficult, as the staff of one office must possess, or have ready access to, a myriad of legal, technical and curatorial advisors, including conservation scientists, conservators, subject-area specialists, legal experts, police, Customs officials, embassy staff, politicians and their staff. Without an identified and acknowledged 'nerve centre', some efforts will be duplicated while other required activities will not be done.

Appendix II

International Association of Dealers in Ancient Art

Code of Ethics and Practice:

12.1. The members of IADAA undertake to the best of their ability to make their purchases in good faith.

12.2. The members of IADAA undertake not to purchase or sell objects until they have established to the best of their ability that such objects were not stolen from excavations, architectural monuments, public institutions or private property.

12.3. The members of IADAA refuse to dismember and sell separately parts of one complete object.

12.4. The members of IADAA undertake to the best of their ability to keep objects together that were originally meant to be kept together.

12.5. The members of IADAA undertake to the best of their ability to keep photographic records prior to repair and restoration, to be honest and open by describing in writing the amount of repair and restoration undertaken to a prospective purchaser.

12.6. Members guarantee the authenticity of all objects they offer for sale.

12.7. Members of IADAA undertake to the best of their ability to inform the Administrative Board about stolen goods and thefts. They also undertake to cooperate with international and national agencies involved with the recovery of stolen goods.

Appendix III

Text of the British *Code of Practice for the Control of International Trading in Works of Art*:

1. In view of the world-wide concern expressed over the traffic in stolen antiques and works of art and the illegal export of such objects, the U.K. fine art and antiques trade wishes to codify its standard practice as follows:

2. Members of the U.K. fine art and antiques trade undertake, to the best of their ability, not to import, export or transfer the ownership of such objects where they have reasonable cause to believe:

a) The seller has not established good title to the object under the laws of the U.K., i.e. whether it has been stolen or otherwise illicitly handled or acquired.

b) That an imported object has been acquired in or exported from its country of export in violation of that country's laws.

c) That an imported object was acquired dishonestly or illegally from an official excavation site or monument or originated from an illegal, clandestine or otherwise unofficial site.

3. Members also undertake not to exhibit, describe, attribute, appraise or retain any object with the intention to promote or fail to prevent its illicit transfer or export.

4. Where a member of the U.K. fine art and antiques trade comes into possession of an object that can be demonstrated beyond reasonable doubt to have been illegally exported from its country of export and the country of export seeks its return within a reasonable period, that member, if legally free to do so, will take responsible steps to co-operate in the return of that object to the country of export. Where the code has been breached unintentionally, satisfactory reimbursement should be agreed between the parties.

5. Violations of this code of practice will be rigorously investigated.

6. This code which is intended to apply to all objects usually traded in the fine art and antiques market and to all persons active in that market has been subscribed by the following organizations:

Appendix IV

Text of the UNESCO *Draft Code of Ethics for Dealers in Cultural Property*:

PREAMBLE

Members of the trade in cultural property recognize the key role that trade has traditionally played in the dissemination of culture and in the distribution to museums and private collectors of foreign cultural property for the education and inspiration of all peoples.

They acknowledge the world wide concern over the traffic in stolen, illegally alienated, clandestinely excavated and illegally exported cultural property and accept as binding the following principles of professional practice intended to distinguish cultural property being illicitly traded from that in licit trade and they will seek to eliminate the former from their professional activities.

ARTICLE 1

Professional traders in cultural property will not import, export or transfer the ownership of this property when they have reasonable cause to believe it has been stolen, illegally alienated, clandestinely excavated or illegally exported.

ARTICLE 2

A trader who is acting as agent for the seller is not deemed to guarantee title to the property, provided that he makes known to the buyer the full name and address of the seller. A trader who is himself the seller is deemed to guarantee to the buyer the title to the goods.

ARTICLE 3

A trader who has reasonable cause to believe that an object has been the product of a clandestine excavation, or has been acquired illegally or dishonestly from an official excavation site or monument will not assist in any further transaction with that object, except with the agreement of the country where the site or monument exists. A trader who is in possession of the object, where that country seeks its return within a

117

reasonable period of time, will take all legally permissible steps to cooperate in the return of that object to the country of origin.

ARTICLE 4

A trader who has reasonable cause to believe that an item of cultural property has been illegally exported will not assist in any further transaction with that item, except with the agreement of the country of export. A trader who is in possession of the item, where the country of export seeks its return within a reasonable period of time, will take all legally permissible steps to co-operate in the return of that object to the country of export.

ARTICLE 5

Traders in cultural property will not exhibit, describe, attribute, appraise or retain any item of cultural property with the intention of promoting or failing to prevent its illicit transfer or export. Traders will not refer the seller or other person offering the item to those who may perform such services.

ARTICLE 6

Traders in cultural property will not dismember or sell separately parts of one complete item of cultural property.

ARTICLE 7

Traders in cultural property undertake to the best of their ability to keep together items of cultural heritage that were originally meant to be kept together.

ARTICLE 8

Violations of this Code of Ethics will be rigourously investigated by [insert name of body]. A person aggrieved by the failure of a trader to adhere to the principles of this Code of Ethics may lay a complaint before that body, which shall investigate that complaint. Results of the complaint and the principles applied will be made public.

Appendix V

Code of Ethics for Professionals Concerned With the Antiquities of the Near and Middle East

This code of ethics was developed on the occasion of the Symposium on the Looted Antiquities of Iraq held in Baghdad in December 1994 and is aimed at all professionals concerned with cultural heritage, most particularly those specializing in the ancient and Islamic Near and Middle East, including archaelogists, art historians, philologists, architects, and scientists and support workers working in connection with archaeological sites or materials. It has been developed in recognition of the enormous destruction to the cultural heritage of this region that has resulted from clandestine digging and looting of archaeological sites and museums and the resulting illegal export and trade in objects, cuneiform tablets and other inscribed items, manuscripts and architectural elements. Not only are such objects removed from their archaeological contexts but the illegal antiquities trade leads to the destruction of many more artifacts and antiquities than are bought to market, since imperfect objects and tablets are discarded and illustrations separated from manuscripts. This destruction is directly encouraged by those, whether as individuals or institutions, who participate in any way in the illegal trade in antiquities. As a first step in stemming this haemorrhage of the cultural heritage of the Near and Middle East, this code of ethics takes as its starting point an affirmation of the Code of Professional Ethics developed by the International Council of Museums, which is appended to this document. The most important paragraphs in the above code which should be extended to include all professionals involved in cultural heritage are 2.11, 3.2, 3.3, 4.2, 4.4, 5.2, 6.3, 6.4, 6.5, 7.1, 7.3, 8.3, 8.5 and 8.6.

Critical principles whether enunciated in that Code or agreed by the present symposium are:

1. No professional concerned with the ancient and Islamic Near and Middle East should acquire, whether by purchase, gift, bequest or exchange, any object, tablet, manuscript or architectural fragment unless that individual can acquire a valid title and can demonstrate that the object was not acquired in or exported from its country of origin and/or intermediate country in which it may have been legally owned, in violation of that country's laws.

119

2. No professional concerned with the ancient and Islamic Near and Middle East should be involved either directly or indirectly in clandestine excavation.

3. No professional concerned with the ancient and Islamic Near and Middle East should identify, authenticate or evaluate material there is reason to believe has been illegally excavated and/or exported.

4. Since no materials should be published or exhibited without permission from the legal owner, no professional concerned with the ancient and Islamic Near and Middle East should publish or exhibit material that there is reason to believe has been illegally excavated and/or exported.

5. No museum or other institution should participate in the sale or transfer of antiquities without informing the Department of Antiquities of the presumed country of origin.

Appendix VI

International Congress for Classical Archaeology

Loans and Acquisitions of Archaeological Objects by Museums
(The Berlin Declaration 1988):

A. Preamble

1. The historical significance of an object in the collection of an art museum or a museum of cultural history is not less important than the material, aesthetic or other values that are applied to it at any particular time.

2. The historical significance of such an object is influenced by such factors as its origin, its function, its functional context, the dissolution of this and whether this is recorded or unrecorded; and in extreme cases even by the object's partial destruction, than by its recognition as a collector's item and its acquisition by a museum or other collection.

3. The most important method of determining the historical significance of an archaeological object from beginning to end is excavation. The most important tool in examining the nature of an archaeological object after its excavation is its record.

4. Furthermore all alterations to the original condition of an archaeological object, especially conservation treatment, display, and changes of location must be recorded. Neglect or loss of this information diminishes the historical significance of an object.

B. New Acquisitions

5. Whereas the contents of museums in countries rich in antiquities are increased by excavation, other museums of antiquities throughout the world are dependent for their vitality, for new displays and for their scientific orientation on special exhibitions, long-term loans, and new acquisitions.

6. The historical significance of objects that appear in the art market or are newly acquired by museums must also be verifiable: for this reason the record of their discovery (excavation) and their subsequent ownership is essential.

7. Destruction or falsification of the details of discovery and preservation of archaeological objects is unacceptable from a scientific point of view. Reconstructing the background of an object from stylistic or other criteria alone can never compensate for the loss of its historical context.

8. In order to discourage the loss of this information and also the further destruction of archaeological sites through unauthorized excavations, the history of previously unknown objects, including their discovery and subsequent ownership, must be thoroughly investigated. Museums must ensure that they do not acquire by purchase or gift, or accept on loan, objects that have recently become available through the illicit market (i.e. that have been acquired in or exported from their country of origin in violation of that country's laws), and therefore lack information on their origin. All archaeologists should avoid aiding this illicit trade by providing authentications or other advice to dealers or private collectors. The responsible authorities are requested to exact legislation with adequate penalties to discourage unauthorized excavations.

C. International Cultural Exchange

9. Given the above conditions, the international exchange of loans should be encouraged, subject always to the constraints imposed by conservation requirements:
 a) for short-term exhibitions intended to reconstruct the historical context of objects of artistic and cultural interest;
 b) for long-term display in museums that comply with international standards.

10. This kind of cultural assistance must be practised in a spirit of mutual collaboration and under strict scientific control. Collaboration includes all kinds of cultural exchange together with scientific or practical accomplishments. Information concerning loans should be published within a reasonable time.

11. The responsible authorities in Museums, Administrations, Local Authorities and Governments are hereby requested to promote cultural exchange of this kind in every possible way, and to publish the policies of acquisitions and loans.

Appendix VII

Swiss Academy of Humanities and Social Sciences and Swiss Liechtenstein Foundation for Archaeological Research Abroad

Principles for Partnership in Cross-Cultural Human Sciences Research with a Particular View to Archaeology:

INTRODUCTION

The Swiss Academy of Humanities and Social Sciences (SAHS) together with the Swiss Liechtenstein Foundation for Archaeological Research Abroad (SLFA) staged an International Symposium on 'Archaeology – a Voice in the Cross-cultural Dialogue between South and North' in Autumn 1994. SLFA had grown from an initiative within the academy. Looking back on an eight years' experience, the need was felt to issue a formal statement covering the ethical aspects of archaeological partnership and of cross-cultural research in general. The Boards of SAHS and SLFA are aware of similar needs and considerations within other national and international scholarly and professional organizations, as well as agencies concerned with cultural co-operation. They are convinced that such cultural collaboration constitutes not just an indispensable complement but rather a prerequisite of any successful development co-operation. Moreover, they believe that another condition of success is co-operation in the form of equal partnership.

Cross-cultural co-operation is a paramount means of preserving and enhancing cultural diversity. Both SAHS and SLFA believe that cultural diversity is as important and significant as biological diversity for maintaining the conditions of humane, peaceful existence of mankind.

Cross-cultural intercourse has to be based on mutual respect as supreme principle. However, examples such as the growing illicit trade in cultural objects show that this is not always the case. Therefore, it seems appropriate and timely to issue a set of guidelines for cross-cultural co-operation, in particular archaeological research, in order to formalize what has already become the concern and practice of many researchers. The following recommendations are addressed, in the first instance, to professionals in cultural fields, such as archaeologists, anthropologists, ethnologists, museum specialists, conservators, etc. Then, in the second place, to the respective professional

organizations which hopefully will find ways and means to enforce the recommendations within their membership. In the third place the guidelines may be relevant for governmental authorities and non-governmental agencies.

SAHS and SLFA would be glad if their effort were of help beyond their national borders and became an object of debate, agreement, and concrete measures on an international level, to the extent still necessary. They are encouraged in this hope by the fact that the guidelines put forward below were discussed and adopted by participants in the symposium who came from all parts of the world.

SAHS and SLFA are aware, of course, of the existence of an impressive number of recommendations, guidelines, codes of ethics issued by various national, regional, and international professional associations, governmental and non-governmental organizations. In fact, many of the respective documents were consulted, and profit was taken from the reflections and statements therein. However, additional rules are needed to meet current needs, taking into account the changes and developments that have occurred since those documents were issued. Much of what was conceived and adopted before stands firm and serves as the ground on which the guidelines below have been constructed.

The following documents provided essential elements:

* the Hague Convention of May 14, 1954, concerning the Protection of Cultural Property in the Event of Armed Conflict;

* UNESCO's Recommendation on International Principles Applicable to Archaeological Excavations, New Delhi, December 5, 1956;

* UNESCO's Declaration of the Principles of International Cultural Co-operation, Paris, November 4, 1966;

* UNESCO's Convention on the Means of Prohibiting and Preventing the Illicit Import, Export, and Transfer of Ownership of Cultural Property, Paris, November 14, 1970;

* UNESCO's Convention concerning the Protection of World Natural and Cultural Heritage, November 23, 1972;

* the Berlin Declaration on Loans and Acquisitions of Archaeological Objects by Museums, July 27, 1988;

* The British Institute of Field Archaeology's Code of Conduct, September 12, 1988;

* ICOMOS' Charter for the Protection and Management of the Archaeological Heritage, Lausanne, 1990;

* the First Code of Ethics of the World Archaeological Congress, Barquisimeto/ Venezuela, September 1990;

* the 'Model for Archaeology 1991' of the Association of Swiss Cantonal Archaeologists;

* the 'Definition of Archaeology' with its corollaries issued by the Association for Roman Archaeology in Switzerland, Martigny, November 5, 1993;

* the USA Society of Professional Archaeologists Code of Ethics, Revised Edition, January 1993;

* the Resolutions adopted at the 1993 Carter Lectures on 'Africa's Disappearing Past';

* the Society of American Archaeology's draft Principles of Ethics in Archaeology, January 24, 1994.

PREAMBLE

1. **The history of culture is embedded in the history of nature.** The historical process, its phenomena, products, monuments, and vestiges in all their diversity deserve no less respect and care than non-human biological diversity within nature.

Cultures consist of human concepts, practices and products. Expressions of cultures take many forms whose significance is never exhausted by their economic value.

2. **Cultural diversity is no less important than biological diversity. The diversity and richness arising from the continuous process of cultural history are sources of great depth and a treasure beyond price.** It is an indispensable resource of self-reassurance, orientation, adaptation, and of social life, the basis of humane existence for present and future generations. This diversity is valued in an environment of mutual respect and coexistence.

3. **Each culture has its own intrinsic worth which must be respected and preserved.** 'Damage to cultural property belonging to any people whatsoever means damage to the cultural heritage of all mankind, since each people makes its contribution to the culture of the world'. Accordingly, preservation of the cultural heritage is the collective responsibility of all peoples. This responsibility entails both duties and rights.

4. **All appropriate means must be taken to safeguard existing cultural forms and to allow for the creation of new ones**. In particular, research, education, and information programmes are to be designed and realized within each community so as to strengthen the appreciation and the respect of the cultural heritage, both created and received, by each people, by their neighbours, and their fellow peoples world-wide. International co-operation with regard to the documentation, the protection, the conservation, and the presentation of the cultural heritage in general is essential. International co-operation is one of the main means of promoting mutual understanding across cultural borders.

5. **A fundamental task of the human sciences is to promote understanding of the uniqueness of, and relations between, cultures and to enhance cross-cultural communication, negotiation, and agreement**. Those working in the human sciences collect, arrange and classify, analyse and interpret the various forms of culture. In doing this, they ought to comply with the following general principles.

PRINCIPLES FOR CULTURAL CO-OPERATION

1. **Culture is a dynamic process which gives rise to the richness and diversity of cultural forms. Each has to be preserved and enhanced for the benefit of future generations**. This principle must be upheld in spite of the recognition that cultural forms may also disappear.

2. **Knowing that the work of a professional from outside the community will inevitably affect cultural forms of the communities in which they work, professionals should not undertake such work without good reasons.**

3. **Professionals will seek to inform the communities of the implications of their work and obtain the consent of the people whose lives and beliefs may be affected.**

 No such work will be undertaken without the formal approval of the competent authorities.

4. **Professionals must not isolate cultural objects from the originating contexts which give them their cultural value, without the prior consent of the community affected or its culturally competent representatives.** In such cases, objects are commonly linked with a specific purpose and are not to be used for other purposes (for instance dating, analysis of material, expertise), nor transferred to other places.

5. **Professionals shall contribute to making cultural forms accessible to as many persons as possible, while ensuring that respect for the culture is maintained**. Proccessionals must engage in teaching, information, and exhibition programmes designed to convey to the members of the concerned communities the significance of their cultural findings and the importance of their preservation. Contributing to mutual understanding and respect between cultures is an activity intrinsic to the human sciences.

6. **Professionals should establish, as far as possible, an equal partnership with colleagues from the cultural area they investigate**, and whenever possible promote scientific capacity building within the communities concerned. They must strive for co-operation in research, evaluation, and presentation of the research process and its findings.

7. **Professionals should actively support community based, national, and international measures for the protection of cultural heritage**. They should facilitate international exchange, short-term and long-term loans of cultural objects.

8. **Professionals must not take any action which may contribute to illicit trade in cultural objects. In particular, they refrain from forming a personal collection of cultural objects in the field of their research.**

GUIDELINES FOR ARCHAEOLOGISTS ENGAGED IN CROSS-CULTURAL ACTIVITIES

With respect and in addition to the above mentioned considerations and principles, archaeological research in foreign countries shall specifically comply with the following rules:

A. At the Service of the Archaeological Heritage

1. **Archaeologists do not seek objects as such, but scientific information.** The main object of archaeology is knowledge of past human existence based on interpretation of material remains and their context considered in the widest sense to include the natural environment.

2. **Archaeologists should protect and preserve the archaeological heritage.** Damage or destruction of archaeological objects and sites and their context must be limited to the strictly necessary and inevitable.Where investigation may imply destruction or impoverishment of the archaeological heritage, it shall be conducted only where knowledge is requested by the cultural communities affected and where there is no other way of acquiring such knowledge; or when sites are threatened by development or natural events. Wherever adequate, non-destructive methods, such as aerial and ground surveys, and sounding, must be encouraged and preferred to complete excavation. Sounding and careful evaluation must precede excavation.

3. **Archaeologists must inform themselves about and abide by the legal and professional rules valid in their host country, and they must respect its corresponding professional institutions, with which they cooperate.**

4. **Archaeologists must never lend their professional competence, directly or indirectly, to illegal and unethical undertakings.** They must not evaluate or provide any expertise for such activities. They shall not purchase or accept objects thus obtained, either for themselves or for any private or public person or institution.

5. **Archaeological investigation should always strive for optimal performance.** In emergency conditions, perfection may not be obtainable. All excavations must, however, be fully documented.

6. **Archaeological excavations in foreign countries are legitimate and admissible only under the following conditions: 1. if investigation, analysis, interpretation, documentation, and publication are assured. 2. and if the objects found can be conserved and, by bilateral agreement, presented and/or stored in an appropriate place, preferably within reasonable reach of the communities concerned.**

7. **Before beginning field work, archaeologists must discuss the maintenance of the site after excavation with the relevant authorities, give appropriate advice, and also prepare and take preliminary action.** The safety of all sites must be ensured. As far as possible, they shall ensure that those sites are protected from looting. If proper maintenance cannot be guaranteed, the researched area shall be completely covered after excavation, with the agreement of the competent authorities.

8. **'Archaeologists should consider maintaining untouched, partially or totally, a certain number of archaeological sites of different periods in order that their excavation may benefit from improved techniques and more advanced archaeological knowledge.'** This rule does not apply where remains are in danger of destruction or disappearance.

B. Consideration for the Communities Concerned

9. **When planning archaeological campaigns abroad, archaeologists must identify the communities whose cultural heritage is the object of planned investigations and gain their informed consent.** In doing this, archaeologists take into account that the relationship between communities and their cultural heritage exists irrespective of legal ownership or formal official competence.

10. **Archaeologists must always take into account the respect the communities concerned have for sites, places, objects, and human remains.** In setting their research objectives archaeologists should endeavour to take into account possible interests, wishes, questions, goals and priorities put forward by the communities concerned.

11. **When dealing with material from foreign cultures, archaeologists**

shall respect the methods of the communities affected in inter-preting, curating, managing, and protecting the archaeological heritage. The information thus obtained is to be used as a valuable resource in their own interpretative and analytical work.

12. Archaeologists working in a foreign culture must behave as care-fully, circumspectly, and reservedly as possible, avoiding any sign of cultural bias. They are aware that, by their very presence and sojourn, they themselves import alien cultural patterns and behaviour which may violate the life form of their hosts and induce conflicts.

C. Partnership

13. Archaeological investigation in a foreign country should always take the form of equal partnership, particularly with the indigenous specialists. In each project, an adequate part of the employed funds and time will be spent on capacity building with a view to establishing the necessary infrastructure and to training indigenous people in all fields related to archaeological activity, including museum work.

14. Archaeologists working in foreign countries should, if requested, undertake consulting tasks in order to help their colleagues and the country's officials integrate archaeological developments in policies of social, cultural, and technical change, thereby facilitating the setting of priorities.

They support the host country – on demand and within the range of their personal, material, and financial capacity – in assisting projects of technical, economic and social development by archaeological evaluation and consult-ing, the main object of which is to prevent archaeologically relevant sites, places, and objects from being unnecessarily impaired or destroyed.

D. Information, Documentation, Publication

15. The process and the findings of archaeological campaigns in foreign countries must be documented, interpreted, and published follow-ing international standards in a reasonably short time after comple-

tion of the excavation.
Archaeological work and findings, particularly documentary records and primary field data, are of public interest, not commodities to be exploited for personal enjoyment and profit, and not private property. Not only because, as a rule, they are supported by public funds but especially because they are of public concern since they deal with social, political, and cultural history, and thus with the identity of the respective communities. Archaeologists may withhold their findings for a limited time which, however, must not exceed the period indispensable for sound scientific evaluation. They shall deposit a copy of their field notes with the competent authorities of the host community. They shall forward a preliminary report within two years of concluding field work, and a full and detailed record not later than eight years after the preliminary report. When applying for research grants or otherwise securing the financial basis of their research projects, they must take the necessary steps to that end. Failing timely publication, their material and findings are at the free disposal of the competent scientific community.

16. **Archaeologists shall inform the general public within the host country as early as possible by all suitable means (including publication, presentation, and through the mass media, lectures and guided visits) of the existence and, later, the results of an archaeological campaign.** Information may be withheld if its publication might result in plundering and destruction of archaeological sites.

Archaeologists working within foreign cultures ought to participate in the related information process. They are responsible, in co-ordination with the local antiquities authorities, for the publication of the results and their historical significance, marked by deference and respect, and for producing reports in a clear straightforward language understood by the communities affected.

17. **Archaeologists working abroad should ensure that the results of their investigations become known and that after publication field notes and data are made available to the professional community, and the relevant authorities in their own country and the international scientific community.**

18. Archaeologists must fully inform the public, as well as the competent authorities, about pillage of and negligent damage to the archaeological heritage.

19. Archaeologists must themselves prepare, and assist the appropriate authorities to prepare, information on stolen cultural property, which is to be notified to appropriate national and international agencies such as UNESCO and INTERPOL.

20. Archaeologists engaged in cultures other than their own should work for international exchange and short-term or long-term loans of cultural objects, provided this is helpful for education, mutual understanding, historic and aesthetic enjoyment, or scientific purposes, and on condition that conservation requirements are fulfilled.

The participants of the International Symposium on 'The Part of Archaeology in the Cross-Cultural Dialogue'

Rüschlikon, Zürich, September 30, 1994

Appendix VIII

Extract from McIntosh, R.J.; Togola, T. and McIntosh, S.K. 'The Good Collector and the Premise of Mutual Respect Among Nations' (1995) *African Arts* (Autumn) 60 (footnotes omitted).

The Good Collector

The Good Collector may be recognized by a number of characteristics:

1) While motivated to collect by a love of the art and of aesthetics, the Good Collector considers his or her collection to be principally a vehicle to open the eyes of others to the value and nobility of the maker culture. Collection is an expression, first and foremost, of respect.

2) For the Good Collector, pride in the collection comes not from the fact of possession, but from the employment of the collection for knowledge. That knowledge can take one or both of two forms. Knowledge to be gained from collections can take the form of the expanding understanding that scholars can derive about the maker culture. Or collections can be the source of knowledge to be transmitted to a wider, lay audience by the public presentation and interpretation of artifacts of the maker culture. Ethical collecting can provide another lens on social history.

3) While asserting that an aesthetic facility, 'having an eye' for art, is an important tool for scholarship, the Good Collector would never claim that assembling a collection on aesthetic principles could ever justify the destruction of the archaeological context of any item by the act of illicit or unscientific, methodologically substandard recovery. The knowledge of that context, gained by careful excavation, proper recording, and unencumbered publication, is necessary for the scientific and historical appreciation of the maker culture's adaptation to its natural and social environment, its technological and political organization, and its world of beliefs. The Good Collector will always reject the specious argument that the appreciation of beauty need necessarily conflict with the search for knowledge.

4) The Good Collector casts a jaded eye upon those dealers who 'insist that

their reputation take the place of details of provenance'.

5) The Good Collector will actively demonstrate a willingness to join with like-minded collectors to self police the art market. As a necessary part of this action, they will wrest the dialogue about the ethics of collecting and about relations of source and market nations from the trafficking syndicates and their apologists, where that dialogue about essential ethics is presently lodged.

6) The Good Collector will be willing to ennoble his or her own country by questioning those who would define power in international relations as the right to strip other nations of their sense of identity with and pride in their past. She or he would be willing to take an active and thoughtful role in the effort to build mutual respect among nations.